PRACTICAL ART SCHOOL

PRACTICAL
OIL PAINTING

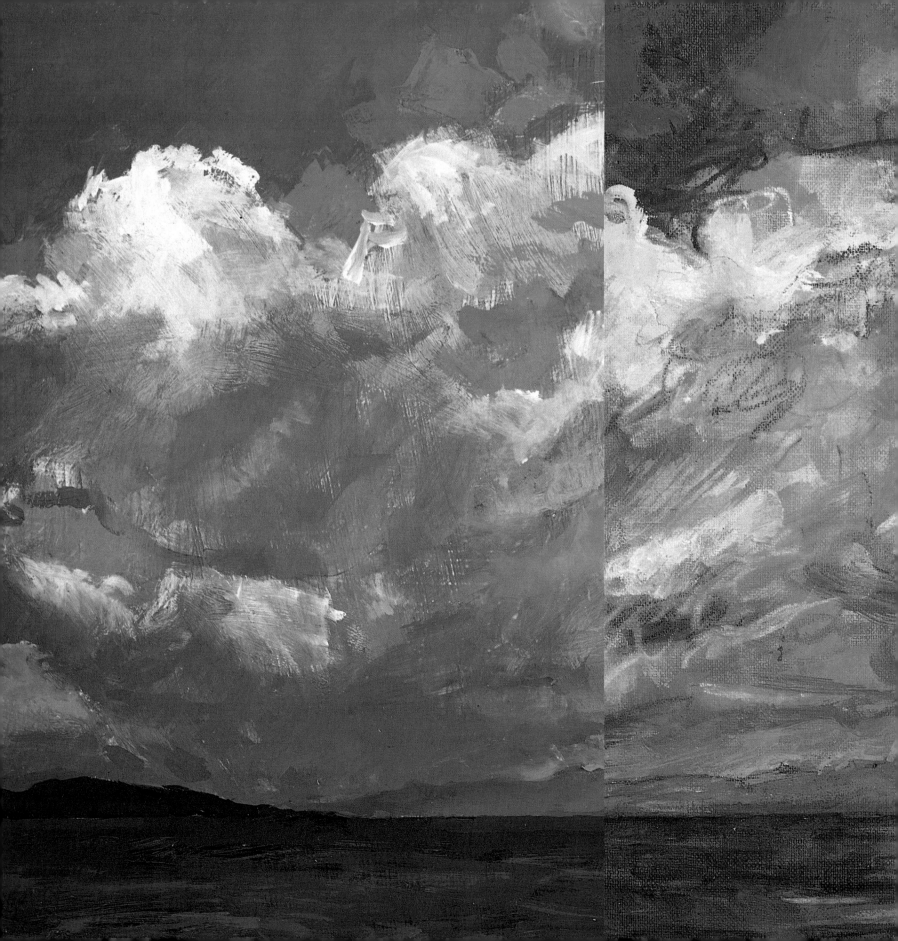

PRACTICAL
OIL PAINTING
GERALD WOODS

The Comprehensive Guide to
Materials and Techniques

COURAGE
BOOKS
AN IMPRINT OF RUNNING PRESS
PHILADELPHIA · LONDON

OIL PAINTING

CLB 4080

9 8 7 6 5 4 3 2 1
Digit on the right indicates the number of this printing.

Library of Congress Cataloging-in-Publication Number 95–70137

ISBN 1–56138–564–6

This book was designed and created by The Bridgewater Book Company Ltd
Designed by Peter Bridgewater / Annie Moss
Edited by Viv Croot
Managing Editor Anna Clarkson
Photography by Zul Mukhida
Typesetting by Kirsty Wall

Color separation by Scantrans PTE Ltd, Singapore
Printed and bound in Spain by Graficas Estella

Published by Courage Books,
an imprint of Running Press Book Publishers
125 South Twenty-second Street
Philadelphia, PA 19130–4399

Contents

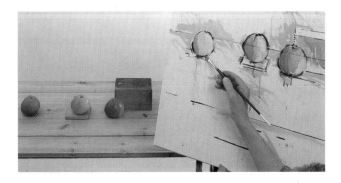

At-a-Glance Guide

Introduction

I am always fascinated by those television programs that feature a well-known cook or chef demonstrating the various stages in producing some gastronomic delight according to a prescribed recipe. Having assembled all the different ingredients together, they blend and mix them together with a deftness and panache that can come only from years of experience.

The English artist Walter Richard Sickert (1860–1942) once said that painting was a bit like cooking: once you've got the ingredients right, the actual cooking of the dish is not too difficult. Continuing the analogy, he also advised that oil paints should be mixed to the consistency of soft butter. This book, like most books concerned with painting techniques, is essentially a recipe book. I would, therefore, consider it as a mark of success if, in a year or so, I were to discover a copy covered with accretions of paint!

The first two sections of the book are concerned with materials, techniques, media and ways of handling them. The handling of a medium is, of course, personal to the artist and his or her work is often recognized by distinctive brushmarks. The better informed you are about technique, the more confident you feel in executing the finished painting – the cook who mixes the ingredients too tentatively produces a dish that is less than appetizing! The preliminary exercises in mixing and using color are, therefore, a necessary prerequisite to making paintings that look as though they have been produced

with ease. Giorgio Vasari (1511–1571) put it more eloquently when he said, "The work should attain perfection without any appearance of effort, without the spectator feeling any of the pangs suffered by the painter making it."

The main aim of this book is to demonstrate ways of producing oil paintings that are personal inasmuch as they are part of the way you really see life. We tend often to forget that the artist never paints things as they are, but as he or she sees them.

The project section of the book is invaluable in that it demonstrates how three artists, working from the same subjects, interpret what they have seen individually – often producing paintings that are strikingly different in style and use of color and tone – even though they have shared the same source of reference.

The critique of each project highlights both positive and negative aspects of each painting, and also illustrates how each artist is able to deal better with some subjects than others.

Finally, I hope that, inspired by these examples, the reader will feel sufficiently encouraged to begin painting – inevitably some attempts will fall short of the intended result, but often this process leads to new discoveries and new forms of expression.

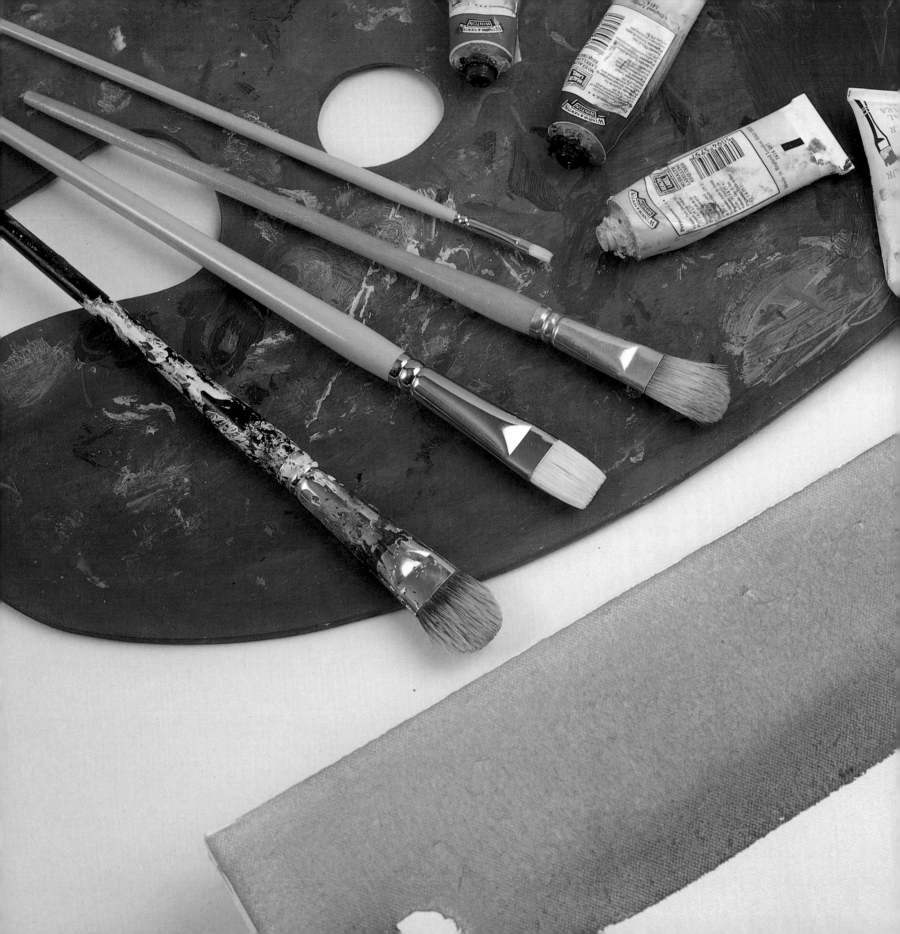

MATERIALS AND TECHNIQUES

The Studio

The word "studio" has all kinds of romantic associations. The French word *atelier,* which means workshop, is probably more relevant. Most artists, however, have to make use of whatever space is available – which might not be much more than the kitchen table! It is, however, always fascinating to see an artist's place of work; Alexander Liberman's book, *The Artist in his Studio* (1960), offers a unique insight into the studios of such artists as Pierre-Auguste Renoir, Pierre Bonnard, Henri Matisse, George Braque, and many others. In Braque's studio in Varengeville, Normandy, for example, the immense room was completely cut off from the outside world. Instead of clear panes of glass, the windows were opaque. Everything was ordered, and spaces were divided according to their function. Sources of inspiration included objects found on the nearby beach – pebbles, pieces of driftwood, starfish, and bleached bones. The walls were covered with paper cutouts, Indian rugs, Polynesian shields, and Etruscan sculpture. Brushes and pencils were laid out in order on slats of corrugated cardboard, oil cans served for mixing color, and palettes were attached to a tree-trunk attached to the floor.

Don't be deterred by lack of space – a vast studio is necessary only if you intend to produce paintings on a very large scale. Diffused light is ideal for oil painting and is easy to achieve. Simply cover the lower part of the window in your studio with tissue paper taped to the frame.

You will obviously need a good solid working table for stretching canvas and priming. In addition, you might also prefer a painting table to a hand-held palette. You will need storage space for materials and, if space allows, a rack for finished canvases and frames. Map drawers are very useful for storing drawings to keep them flat. Other painting materials can also be stored in them.

A well-ordered studio with everything in its place and divided according to function. The venetian blinds provide diffused light, which is ideal for oil painting.

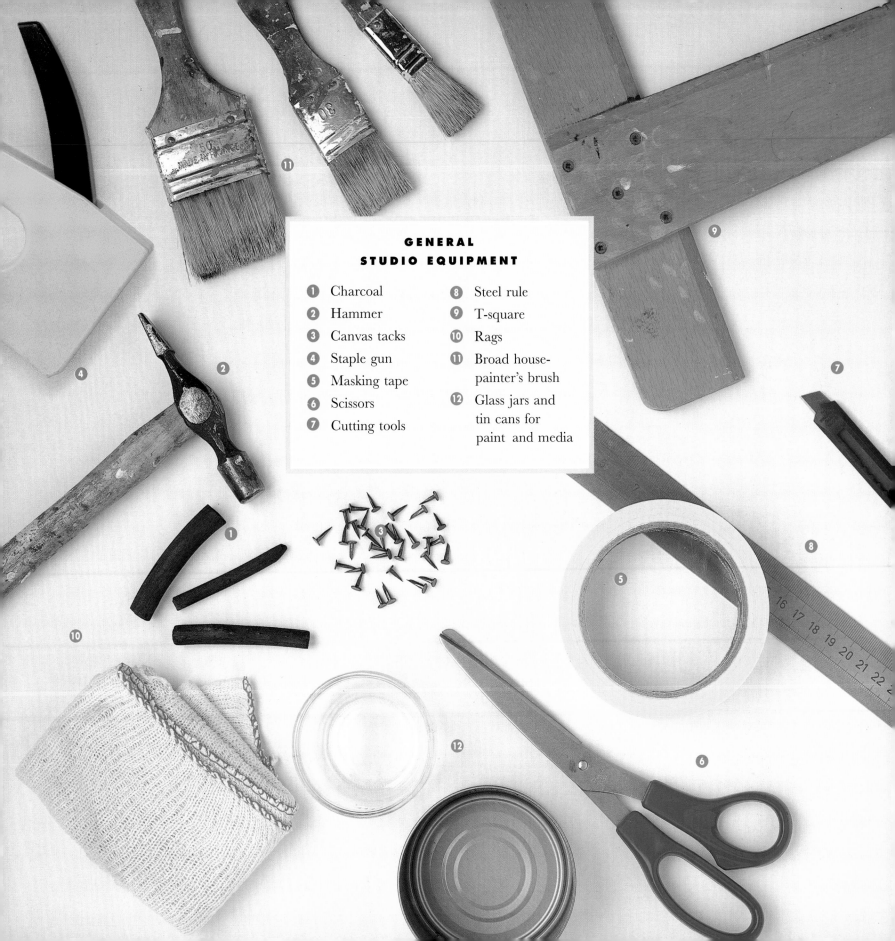

GENERAL STUDIO EQUIPMENT

1. Charcoal
2. Hammer
3. Canvas tacks
4. Staple gun
5. Masking tape
6. Scissors
7. Cutting tools
8. Steel rule
9. T-square
10. Rags
11. Broad house-painter's brush
12. Glass jars and tin cans for paint and media

Canvas and Other Supports

A support is the name given to the various supporting surfaces on which all oil paintings are carried out. The primary function of a support is to provide a stable and solid surface that will readily receive whatever technique or medium you intend using. Wood panels, stretched canvas, hardboard (Masonite), canvas board, compressed fiberboard, cardboard, and metal are all supports.

When considering which type of support would be most suitable for your own purposes, focus on factors such as weight, size and cost, as well as surface qualities of different kinds of materials.

WOOD PANELS

Historically these are the oldest type of supports, although they were largely replaced by stretched canvas during the Renaissance. Many varieties of wood are suitable; however, hard woods such as mahogany are more stable than softer woods, which are liable to warp.

All wood panels should be cut from well-seasoned wood and be free from cracks or knots. Thin panels can be given additional strength by screwing battens to the reverse side. If well-seasoned wood is difficult to obtain, you could salvage old furniture, particularly door panels.

The weight of a large wooden panel could prove to be a problem for the landscape painter, although small panels are eminently suitable for painting directly from nature.

HARDBOARD

Hardboard (or Masonite) is mid-brown or dark brown in color and is made from wood-pulp compressed into thin sheets. This type of board is perhaps the most widely used support for oil painting, because it is inexpensive, lightweight, and strong. Many people make the mistake of using the textured side of the board, probably because it is akin to the texture of canvas. The somewhat

Supports for oil painting include, from top to bottom, stretched linen canvas, canvas board, cardboard, hardboard, and sanded plywood.

mechanical "tooth" is very pronounced, however, and will dominate the painting unless a thick impasto is applied. The smooth side is preferable, but should be sanded slightly to make the surface more receptive to primer.

PAPER AND CARDBOARD

Rembrandt van Rijn, Eugène Delacroix and Paul Cézanne all occasionally used paper as a support. A good-quality rough-surface watercolor paper is ideal, and can be given additional stability by being stuck down onto board. A thin coating of gesso primer painted on both sides of the paper will counteract its absorbency. One note of caution is that unsized and unprimed cardboard tends to attract fungus and mildew unless stored in dry conditions, or framed and sealed behind glass.

OIL SKETCHING PAPER

This is a commercially produced paper that comes already primed and has a canvaslike texture. It is useful for landscape and figure studies, although some people are put off by the rather mechanical texture of the surface.

CANVAS

This is the traditional support for oil painting and the one most favored by professional artists. Fine and coarse weaves of cloth offer a variety of surfaces. The characteristic "tooth" of the canvas is, when primed, particularly responsive to oil paint.

A stretched canvas is light and easy to transport and can, if necessary, be taken off the stretcher and rolled up for storage.

The finest canvas is made from linen, which has a fine weave and is less liable to shrink or stretch than other materials. Cotton canvas is more economical but is generally softer and more prone to distortion. A professionally prepared cotton canvas, however, is adequate for most purposes, and less expensive than linen.

STRETCHING A CANVAS

The drumlike tautness of canvas is achieved by stretching it over a wooden frame called a stretcher. If you are a skilled woodworker and have adequate mitering equipment, you may prefer to make your own stretchers. The mitered corners of each length must be slotted and the edges beveled so that they do not press against the stretched canvas. Ready-made stretcher pieces can be bought in standard sizes and very quickly put together.

❶ *Cut the canvas with an overlap of 2 inches all around the assembled stretcher. Make sure that the stretcher is completely square, and that all the bevels are on the same side.*

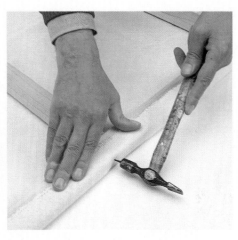

❷ *Tack the center of one side firmly in position with a tack hammer. You could also use a staple gun if preferred.*

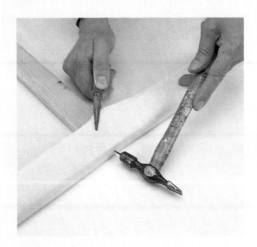

❸ *Stretch the canvas taut and tack the opposite side in the center. Continue working in this way from one side to the other and left and right of the center.*

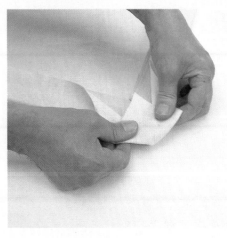

❹ *Fold the remaining flaps neatly over at each corner of the stretcher as shown above.*

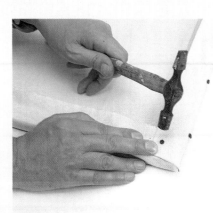

❺ *Tack down each corner. Finally, knock the wooden wedges (which are supplied with stretchers) into the gaps on each miter, two to each corner.*

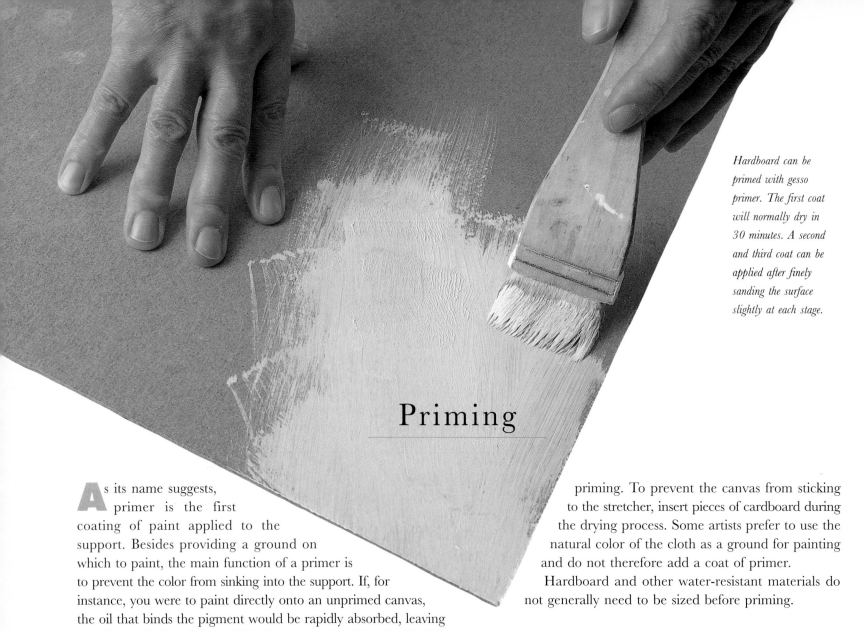

Hardboard can be primed with gesso primer. The first coat will normally dry in 30 minutes. A second and third coat can be applied after finely sanding the surface slightly at each stage.

Priming

As its name suggests, primer is the first coating of paint applied to the support. Besides providing a ground on which to paint, the main function of a primer is to prevent the color from sinking into the support. If, for instance, you were to paint directly onto an unprimed canvas, the oil that binds the pigment would be rapidly absorbed, leaving a residue of color that is difficult to control with a brush. Oil paint has a tendency to darken with age, but a coat of white primer will help to ensure that the tone and brilliance of the color is retained.

SIZING

Before the canvas or support is primed it should be given a coating of size. The best size is made from rabbit-skin glue, available in crystal form from artists' materials stores. The sheets of glue or crystals should be dissolved in warm water and stirred until liquid. (When cold, it should be the consistency of soft jelly.) The size is applied while still warm, and allowed to dry thoroughly before

priming. To prevent the canvas from sticking to the stretcher, insert pieces of cardboard during the drying process. Some artists prefer to use the natural color of the cloth as a ground for painting and do not therefore add a coat of primer.

Hardboard and other water-resistant materials do not generally need to be sized before priming.

WHICH PRIMER?

Traditionally, the main priming pigment for oil painting is white lead, to which glue size and boiled linseed oil is added. The toxic nature of white lead, however, has proved to be a health risk. Titanium White or Zinc White are generally used now.

The introduction of ready-mixed acrylic grounds has made life easier for those artists who do not wish to spend a lot of time on preparation. Acrylic gesso dries rapidly and provides a fine, matt, white surface that is very receptive to brush marks.

If you are applying two or three coats of primer to your support, allow each coat to dry thoroughly, and sandpaper any uneven patches. Gesso primer can be given a final polish with a damp rag.

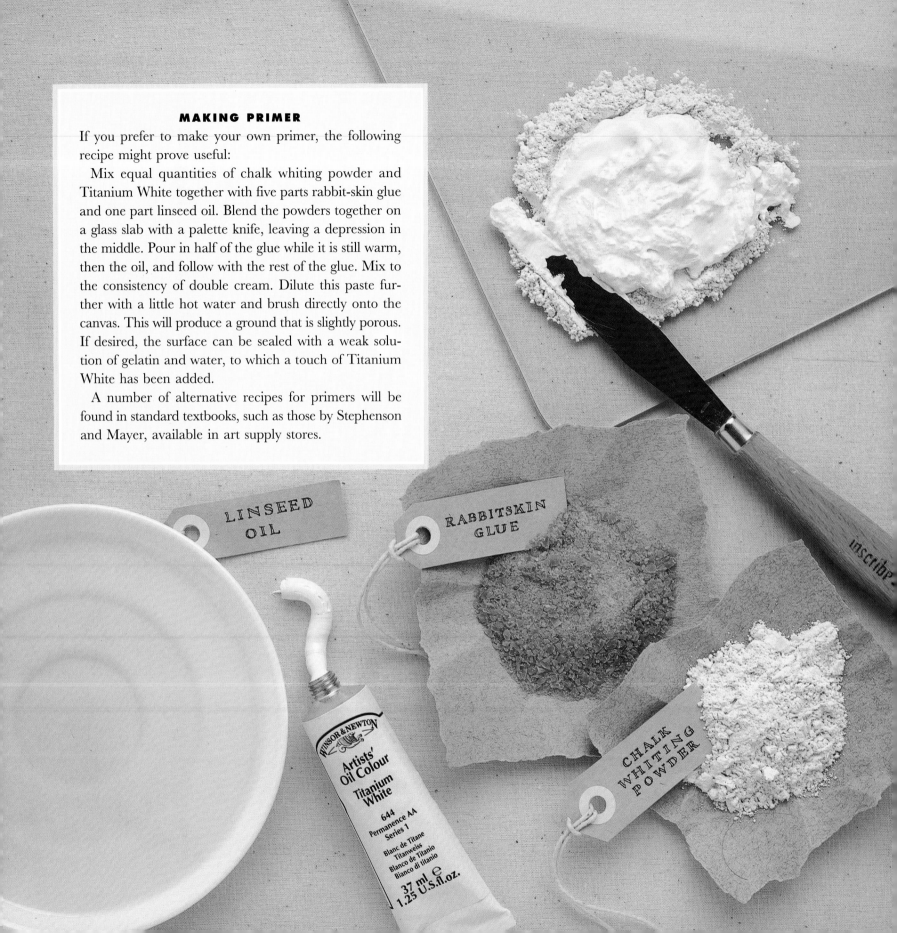

MAKING PRIMER

If you prefer to make your own primer, the following recipe might prove useful:

Mix equal quantities of chalk whiting powder and Titanium White together with five parts rabbit-skin glue and one part linseed oil. Blend the powders together on a glass slab with a palette knife, leaving a depression in the middle. Pour in half of the glue while it is still warm, then the oil, and follow with the rest of the glue. Mix to the consistency of double cream. Dilute this paste further with a little hot water and brush directly onto the canvas. This will produce a ground that is slightly porous. If desired, the surface can be sealed with a weak solution of gelatin and water, to which a touch of Titanium White has been added.

A number of alternative recipes for primers will be found in standard textbooks, such as those by Stephenson and Mayer, available in art supply stores.

LINSEED OIL

RABBITSKIN GLUE

CHALK WHITING POWDER

WINSOR & NEWTON

Artists' Oil Colour

Titanium White

644
Permanence AA
Series 1

Blanc de Titane
Titanweiss
Blanco de Titanio
Bianco di titanio

37 ml e
1.25 U.S.fl.oz.

Brushes and Painting Knives

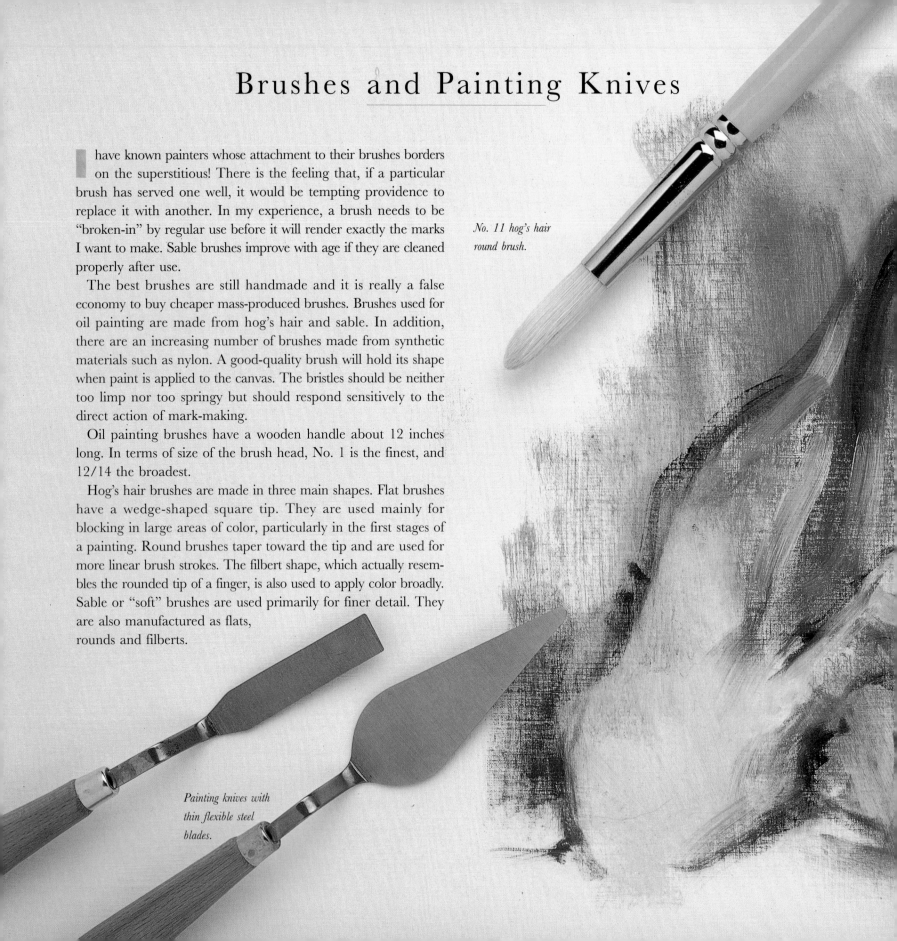

I have known painters whose attachment to their brushes borders on the superstitious! There is the feeling that, if a particular brush has served one well, it would be tempting providence to replace it with another. In my experience, a brush needs to be "broken-in" by regular use before it will render exactly the marks I want to make. Sable brushes improve with age if they are cleaned properly after use.

The best brushes are still handmade and it is really a false economy to buy cheaper mass-produced brushes. Brushes used for oil painting are made from hog's hair and sable. In addition, there are an increasing number of brushes made from synthetic materials such as nylon. A good-quality brush will hold its shape when paint is applied to the canvas. The bristles should be neither too limp nor too springy but should respond sensitively to the direct action of mark-making.

Oil painting brushes have a wooden handle about 12 inches long. In terms of size of the brush head, No. 1 is the finest, and 12/14 the broadest.

Hog's hair brushes are made in three main shapes. Flat brushes have a wedge-shaped square tip. They are used mainly for blocking in large areas of color, particularly in the first stages of a painting. Round brushes taper toward the tip and are used for more linear brush strokes. The filbert shape, which actually resembles the rounded tip of a finger, is also used to apply color broadly. Sable or "soft" brushes are used primarily for finer detail. They are also manufactured as flats, rounds and filberts.

No. 11 hog's hair round brush.

Painting knives with thin flexible steel blades.

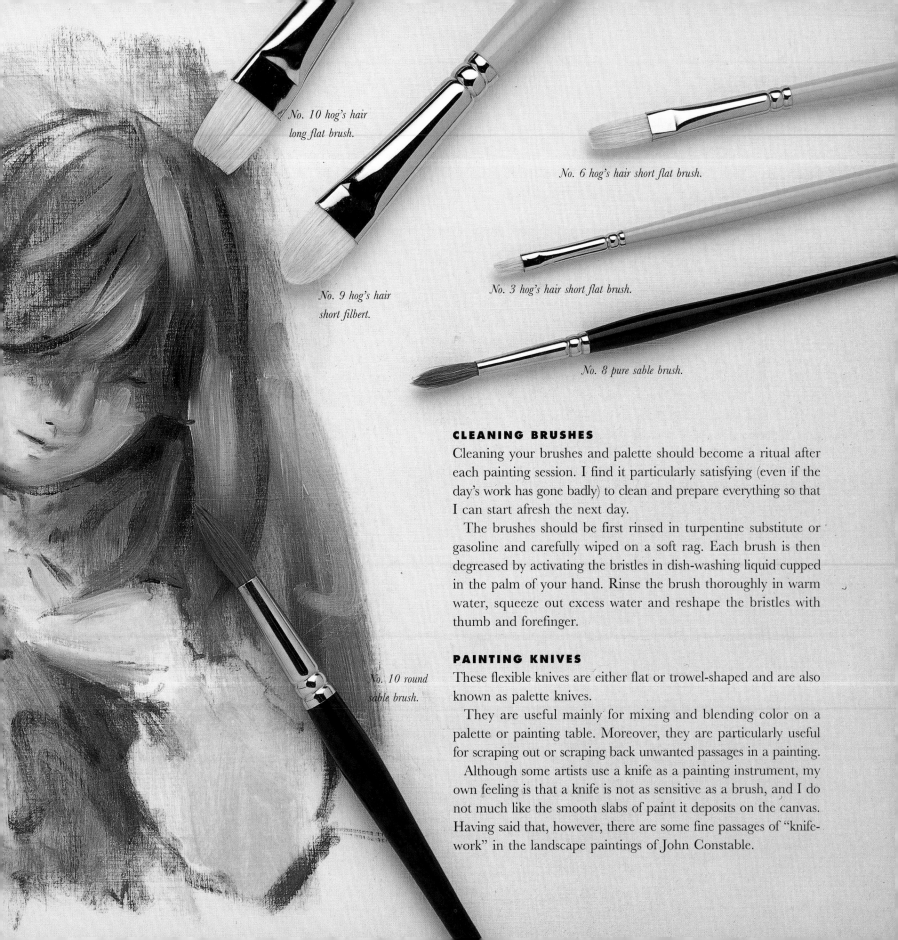

No. 10 hog's hair long flat brush.

No. 6 hog's hair short flat brush.

No. 9 hog's hair short filbert.

No. 3 hog's hair short flat brush.

No. 8 pure sable brush.

No. 10 round sable brush.

CLEANING BRUSHES

Cleaning your brushes and palette should become a ritual after each painting session. I find it particularly satisfying (even if the day's work has gone badly) to clean and prepare everything so that I can start afresh the next day.

The brushes should be first rinsed in turpentine substitute or gasoline and carefully wiped on a soft rag. Each brush is then degreased by activating the bristles in dish-washing liquid cupped in the palm of your hand. Rinse the brush thoroughly in warm water, squeeze out excess water and reshape the bristles with thumb and forefinger.

PAINTING KNIVES

These flexible knives are either flat or trowel-shaped and are also known as palette knives.

They are useful mainly for mixing and blending color on a palette or painting table. Moreover, they are particularly useful for scraping out or scraping back unwanted passages in a painting.

Although some artists use a knife as a painting instrument, my own feeling is that a knife is not as sensitive as a brush, and I do not much like the smooth slabs of paint it deposits on the canvas. Having said that, however, there are some fine passages of "knife-work" in the landscape paintings of John Constable.

Easels

It is perfectly possible to work on oil paintings without an easel; indeed, some artists prefer working in a less formal way on an old table. Nevertheless, for the professional artist or serious amateur, a studio easel is a worthwhile investment. A well-made studio easel will hold your canvas or board in a rigid position, the height can be adjusted for a standing or sitting position, and the easel can be moved to any position to catch the best light.

A studio easel is usually constructed from a rigid H-shaped vertical frame set into a base that is moved on castors. The canvas rests on a shelf, which sometimes incorporates a compartment for brushes and colors. A sliding block holds the canvas firmly in position at the top.

The canvas is moved up and down by means of an adjustable ratchet, which may also be tilted backward or forward from the vertical to give greater flexibility. Some easels adjust so that the canvas can lie horizontally for watercolor work.

RADIAL EASELS

This is the type of easel most commonly used in art schools, especially in the life-painting studio. The upright column is held by a large locking wing-nut connected to three short tripod legs. By loosening the wing-nut, the column can be tilted backwards or forward. The canvas rests on an adjustable shelf and is held at the top by a sliding block.

SKETCHING EASELS

These folding easels are made primarily for landscape painting. They combine lightness, strength and simplicity. Made either from beechwood or a lightweight metal such as aluminum, they can accommodate a canvas height of 34 inches. There is no reason why this type of easel should not also be used in the studio, provided that the spiked tripod legs are supported by blocks or an old carpet or rug.

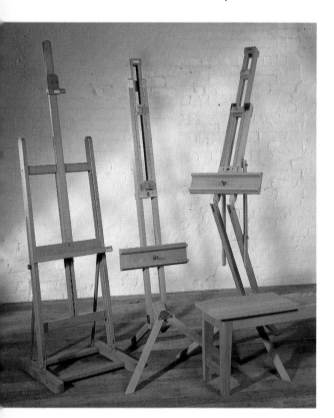

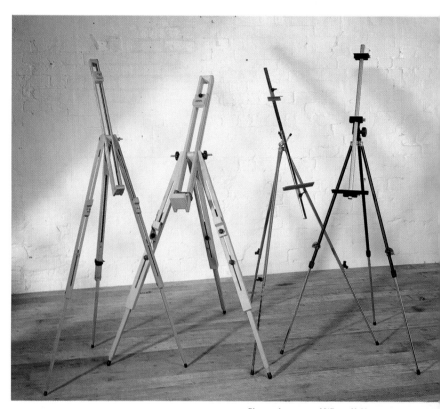

LEFT *Studio easels. The self-assembly easel (far left) has an adjustable lower shelf. The beechwood radial easel (center) tilts to provide different working positions. The tilting radial easel (right) has a central pivotal joint so the canvas can be fixed in any position.*
RIGHT *Sketching easels. The lightweight beechwood easel (right) can be tilted to any angle. A more robust version is shown in the center. Two lightweight metal folding easels (far left) with telescopic legs.*

Photographs courtesy of Winsor & Newton

Palettes

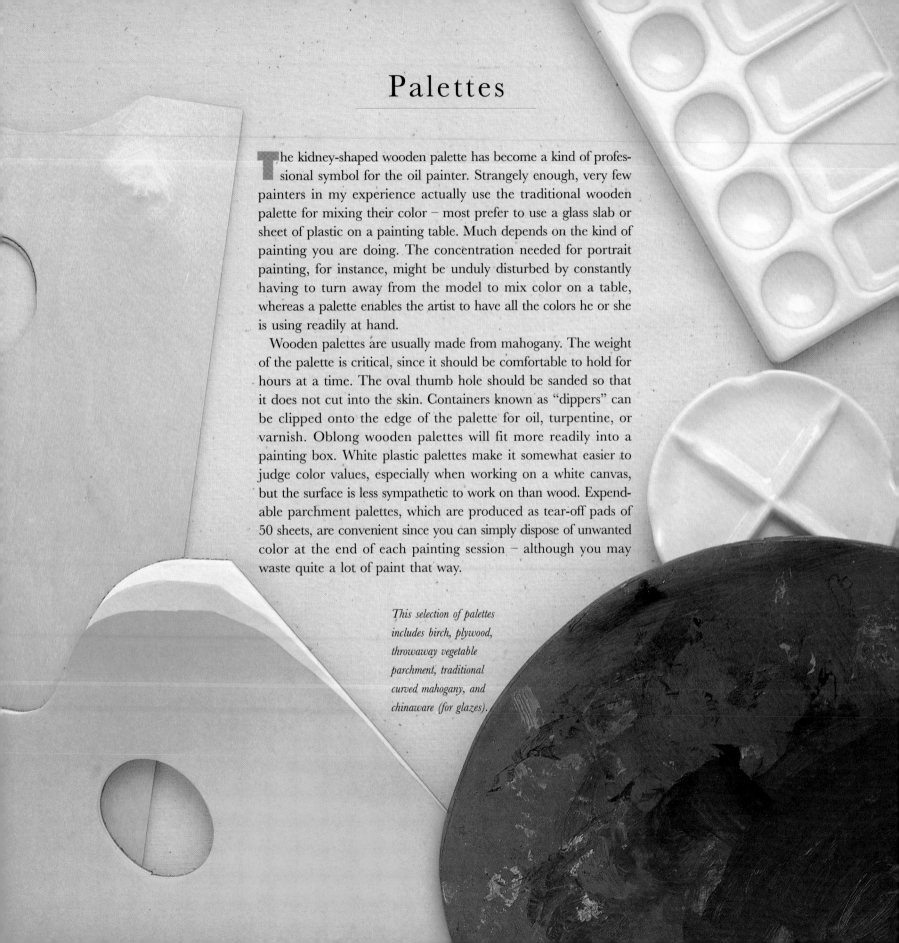

The kidney-shaped wooden palette has become a kind of professional symbol for the oil painter. Strangely enough, very few painters in my experience actually use the traditional wooden palette for mixing their color – most prefer to use a glass slab or sheet of plastic on a painting table. Much depends on the kind of painting you are doing. The concentration needed for portrait painting, for instance, might be unduly disturbed by constantly having to turn away from the model to mix color on a table, whereas a palette enables the artist to have all the colors he or she is using readily at hand.

Wooden palettes are usually made from mahogany. The weight of the palette is critical, since it should be comfortable to hold for hours at a time. The oval thumb hole should be sanded so that it does not cut into the skin. Containers known as "dippers" can be clipped onto the edge of the palette for oil, turpentine, or varnish. Oblong wooden palettes will fit more readily into a painting box. White plastic palettes make it somewhat easier to judge color values, especially when working on a white canvas, but the surface is less sympathetic to work on than wood. Expendable parchment palettes, which are produced as tear-off pads of 50 sheets, are convenient since you can simply dispose of unwanted color at the end of each painting session – although you may waste quite a lot of paint that way.

This selection of palettes includes birch, plywood, throwaway vegetable parchment, traditional curved mahogany, and chinaware (for glazes).

Paint Additives

All oil paints produced in tubes contain a certain amount of linseed or poppy oil, and you need to consider this before further dilution. There are painters who prefer to use oil colors straight out of the tube, thus retaining the essential richness of the colored pigment. In practice, however, most painters discover that they need to reduce the consistency of oil paint in order to achieve full expression in the character of individual brushmarks.

There is a general rule that you should work from thin to fat, though some artists enjoy working in a thick impasto throughout.

There are mainly three ways of reducing the consistency of oil paint: with more oil, with varnish, or with an evaporative essence such as gasoline or turpentine. The most common painting medium is a mixture of distilled turpentine and linseed oil.

For those who, like myself, are allergic to turpentine, oil of spike lavender (available from artists' materials stores) is a suitable alternative – but it is slower to dry.

WHITE SPIRIT

Sometimes known as turpentine substitute, this tends to dull the color, and should be used mainly for cleaning purposes.

LINSEED AND POPPY OIL

This strong and reliable medium is chemically processed in different ways. Cold pressed linseed oil is a slightly yellow oil that is extracted without heat. It increases gloss and transparency while reducing the pigment.

Stand oil (prepared by heating linseed oil or drying it in the sun) is a pale, viscous oil that will retard drying and improve color flow when used in conjunction with turpentine.

Drying linseed oil is of a darker color and will increase the drying rate of oil colors. Sun-bleached poppy oil is a pale, non-yellowing oil useful when painting with whites and pale yellows.

There are numerous commercially formulated painting media, many of which are excellent. As a general rule, however, it is best to use only those that provide some indication of the ingredients used in their manufacture.

VARNISH

Varnishes are used either with other media as part of the painting process or as a protective film for the finished painting. Copal Varnish has been used for many years with oil as a painting medium. It is highly viscous and difficult to handle – it also has a tendency to darken. Damar Varnish is a spirit-based varnish made from the resin of the Damar fir tree dissolved in turpentine. It can be used as a final varnish for the completed painting, producing a waxlike sheen rather than a high gloss. It can also be added to oil and turpentine to produce a painting medium that enriches the color. Mastic is yellowish in color, and has the advantage of drying quickly to produce a high gloss finish. It tends to darken with age and is subject to blooming.

The whole point of giving a painting a final coat of varnish is to protect it from dirt and discoloration. If in turn the varnish becomes dirty, it can be removed with alcohol, and the painting revarnished. That is a slightly risky process, however, since some of the paint might also be removed – especially if varnish has also been used as part of the painting medium.

A coat of varnish will not enhance a bad painting, and might easily spoil a good one.

Before applying varnish, make sure that the pigment in the painting is really hard and free from moisture. The temperature should be even, and the room free from dust.

Warm the painted surface first, using a hairdryer or fan heater. Lay the board or canvas on a flat surface. Pour enough varnish into a dish to cover the whole painting. Using a broad, soft brush, apply the varnish lightly and rapidly under a good light.

A CAUTIONARY NOTE
Observe the correct drying times for all media and varnish.

Linseed oil can take from three to four days to dry, stand oil up to eight days, mastic and copal thirty-six hours.

Oil Paints

24

olored pigments from which oil paints are made are either mineral or organic in origin. Among the natural pigments are the earth colors: yellow, Yellow Ocher, Terre Verte and Ultramarine. Organic animal and vegetable pigments include Carmine, Sepia, the Madders (from the plant of that name), Gamboge, Indigo and Sap Green.

Artificial chemical compounds are the basis for other colors, such as Prussian Blue, Cobalt Blue and Viridian.

Oil paint is made from finely ground pigment held in a binding medium (oil), which enables it to be spread evenly and adhere to a prepared surface. The oil that binds the pigment does not evaporate but reacts to oxygen in the air and, as it dries slowly, it becomes a solid linoxyn. It is only when the oil and pigment are bound together in liquid form that they are soluble. Today, oil paints are sold in air-tight tubes, and if you leave the screw-cap off for any length of time, you will find that the paint will solidify inside the tube. Before the introduction of collapsible tubes, artists had to grind colors afresh for each painting session.

In the manufacture of oil paint there are two basic operations. The raw lumps of pigment must be refined into individual particles and then dispersed in the liquid medium (linseed oil). Large mixing machines known as triple rolling mills are used for the dispersion process. Most colors will pass through the mill several times before they achieve the correct color.

CHOOSING COLORS

Some colors, such as Ultramarine, are still hand-ground on a granite slab with a cone-shaped block of marble or glass called a muller. There are a number of factors to be taken into consideration when choosing colors – the suitability of the color itself for your purposes, the body, density, speed of drying, and the degree of permanence.

Most artists have a predilection for certain colors – whether it be a special color such as Carmine or Naples Yellow, or a range of colors of the same hue. The landscape painter might use an entirely different range of colors from someone who paints seascapes or portraits. For most purposes, however, a basic range of ten to twelve colors will do. Titian, one of the greatest colorists, is said to have observed that a painter needs only three colors in his or her palette!

Technical analysis of Constable's palette at the Tate Gallery in London, England, shows that he used Vermilion, Emerald Green, Chrome Yellow, and Madder. Further examination of his painting of Flatford Mill reveals that he also used Prussian Blue, Yellow Ocher, Raw, and Burnt Sienna.

Artists' color suppliers of repute now provide information in their catalogues concerning the ingredients of their oil paints, as well as the degree of permanence of each color.

WHITES

All the whites are dense and will give added density to transparent colors. Titanium White is used both as a primer, and as a painting pigment. Flake White is made from white lead and is suitable for building up an impasto. Zinc White is fairly intense, but is subject to cracking when dry.

Traditionally, oil paint was freshly mixed for each painting session.

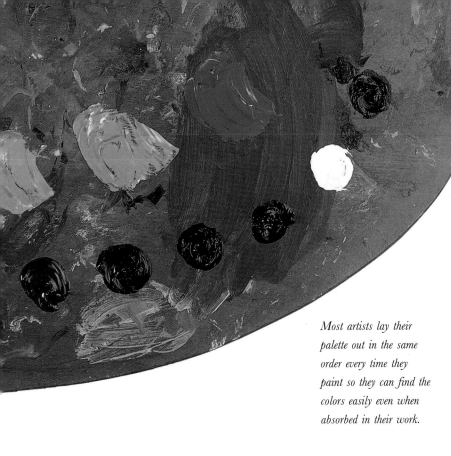

Most artists lay their palette out in the same order every time they paint so they can find the colors easily even when absorbed in their work.

BLUES

Cobalt – a clear mid-blue – tends to look transparent even when applied thickly. Cerulean Blue, a greener blue, is dense and very opaque. Ultramarine is a brilliant, slightly red/blue; it is semi-transparent and should be used with care in relation to other colors. Prussian Blue has a powerful green/blue stain that is very intense. Monastral Blue is a more recent transparent blue, which is permanent and less cold than Prussian Blue.

GREENS

Viridian and Terre Verte are transparent greens – the latter was often used for underpainting by the Old Masters. Cadmium Green is a blend of Cadmium Yellow and Viridian. Cobalt Green is an opaque blue-green pigment; it is weak, with poor tinting strength. Emerald Green is useful for strong opaque tints; it turns black when used with Cadmium Yellow or Vermilion.

YELLOWS

Lemon Yellow is a pale, transparent yellow that has a tinge of green. Chrome Yellow is an opaque yellow with a good covering power. It is supplied in different tones – Chrome Yellow Deep and Chrome Yellow Light. It is not permanent and is poisonous. Cadmium Yellow is more permanent and again is produced in different tones. Indian Yellow is a brilliant transparent yellow. Naples Yellow is opaque, being a blend of Cadmium White, red, and Yellow Ocher.

REDS

Cadmium Reds range in color from a bright yellowish red to a deep red tinged with blue. They have a good degree of permanence and excellent covering power. Alizarin Crimson is an intense red with a hint of crimson – used in low concentrations it can become fugitive. Vermilion is a brilliant, very opaque red. Madder is a delicate crimson color that is used mainly as a tint for other colors. Indian Red has a purple-brown tone – it is opaque with a good covering power. Venetian Red is a rich, dark red; it is opaque and permanent. Carmine is a very pure, transparent pinkish red, but is less permanent than other reds.

BROWNS AND BLACKS

Raw Sienna, which is sometimes considered to be a yellow, is transparent. Burnt Sienna is a red-brown that is permanent. Raw and Burnt Umber are both earth colors – the first is cool, the second warm.

Ivory Black is the most commonly used black, it is very intense and opaque. Lamp Black is slower to dry, but warmer in tone than Ivory Black.

VIOLETS

Cobalt Violet is a transparent color that does not have very much covering power. Ultramarine Violet is a mid-tone with a tinge of blue.

Modern oil paints are sold in air-tight metal tubes.

Brush Techniques

The first marks made on the canvas are as important as the last – there is little point in trying to finish a painting that has started badly or with the wrong intentions. Delacroix felt that the first marks on canvas revealed everything that was essentially significant to the rest of the painting, "The life of the work," he said, "is already to be seen everywhere, and nothing in the development of this theme, in appearance so vague, will depart in the least from the artist's conception: it has scarcely opened to the light, and already it is complete."

The work of a painter is often distinguished by the character of the brushstrokes made on the painting surface. We call this the "handling" of the medium, that part which is most personal to the actual execution of the work. Vincent van Gogh's paintings, for example, are characterized by his use of thick, expressive strokes, which stand in relief on the surface of the canvas. When we look at a painting by Edgar Degas, however, we are more conscious of the quality of the drawn line, particularly in his figure studies.

There is no single method of painting that can be described as the "right" way – the importance lies with the product, not with the method of production. There are, however, ways of handling materials that ought to be explored and practiced by any artist seriously intent on finding a personal means of expression through the medium of oil painting.

The novice painter starts with high expectations, and is all too often put off by early failure. Think about what happens when, having bought all the necessary materials, you tackle the first painting – say a still life. The wedges of color are squeezed out onto the palette looking fresh and untested; a hog's hair brush is dipped into the oil medium, and the coarse bristles take up a little color; the first brushstrokes are made in response to the subject – but the paint isn't behaving as expected – there seems to be a disconnection between what was intended and the quality of the marks that actually appear on the canvas. When things go wrong technically, the concentration tends to go adrift. What usually happens is that you go on hoping that something significant will emerge from the layers of pigment that begin to accrue on the canvas. But by this time, you are no longer in control, and things might get considerably worse before they get better.

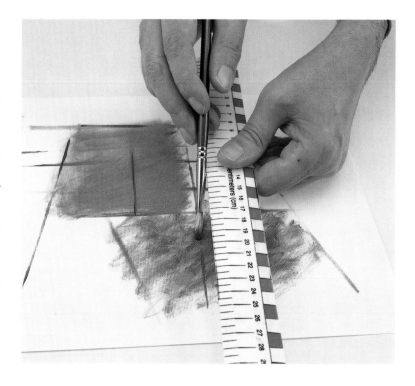

Of course, the difficulties encountered should be seen in a positive light, rather than as a cause of despair. A lack of confidence in handling techniques can be remedied to some extent by a process of familiarization through simple exercises.

First of all, you will need to learn how to control your brushes. If you have ever witnessed a signwriter at work (a rare sight these days!), you will have noticed how the hand moves slowly, but at a constant speed, to follow the curvature of the letterforms. It is a kind of swift, pivotal action from the wrist, which can be practiced by painting spirals and full circles.

Using different actions and different types of brushes you will be able to produce a rich variety of brushmarks and textures – from thin transparent glazes to a dry impasto. For the following exercises, you can use primed hardboard or even cardboard.

USING A MAHLSTICK

A mahlstick is useful as a means of support for the painting hand when adding fine detail to a painting. It allows you to get close

OPPOSITE *A ruler can be used as a brush guide for making straight lines.*

RIGHT *A long hog's hair flat brush is used to practice the pivotal wrist action that helps good brush control.*

BELOW *Scumbling color with a broad house-painter's brush.*

FAR RIGHT *Scumbled color is used to evoke the effect of a storm-lashed coast in this seascape.*

to the painting without smudging it. A piece of ash dowel or bamboo has one end covered with a ball-shaped pad of chamois leather which rests on the canvas, while the end of the dowel or bamboo is supported by the free hand.

DRAWING STRAIGHT LINES

A decorator's yardstick or meter stick is useful as an aid to drawing uprights and horizontals – particularly in architectural subjects. The loaded brush can be run along the edge of the stick as it is held about half an inch from the surface.

SCUMBLING

The scumbling technique involves dragging one dry, opaque layer of paint lightly over another layer of a different color, in such a way that parts of the first layer are still visible through the broken texture of the scumbling. This kind of irregular and unpredictable texture can be seen in the work of many artists, from Joseph Mallord William Turner to Pierre Bonnard. The paint to be scumbled should be brushed out on the palette first until almost

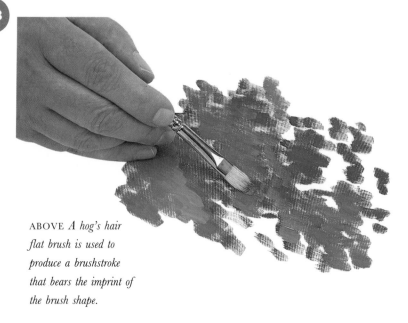

ABOVE *A hog's hair flat brush is used to produce a brushstroke that bears the imprint of the brush shape.*

dry. Since the bristles of the brush tend to be splayed out of shape during this process, it is advisable to use a hog's hair brush rather than a sable which might easily be damaged. The more pronounced the "tooth" of the canvas, the better the effect of scumbling will be.

IMPASTO

When paint is so thick that it stands in low-relief bearing the imprint of the brush that has been used, it is "impastoed." Thick, solid areas of paint are sometimes found under glazes in work by Rembrandt, Turner, Gustave Courbet and others. The paint is best applied without much medium being added. It can be scraped back while still wet, and reworked if necessary.

GLAZING AND STAINING

Glazing is the process of applying transparent layers of oil paint

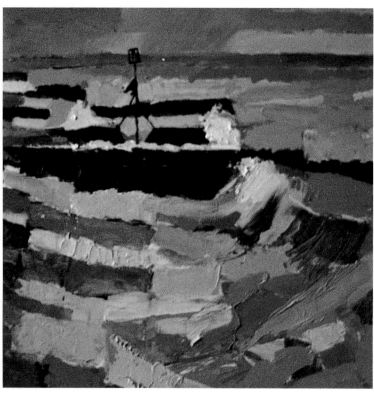

LEFT *In this seascape detail, a heavy impasto has been laid with a painting knife to suggest the layered formation of advancing waves.*

RIGHT *A broad filbert brush is used to produce a bold impasto.*

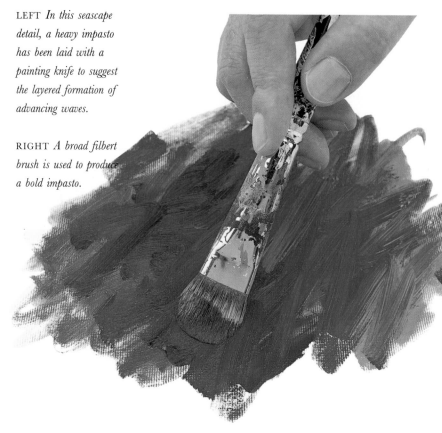

over a solid color, so that the color and tone is distinctly modified. If, for example, a transparent glaze of Carmine Red were to be brushed over Ultramarine, it would produce a rich purple color. Much depends on the thickness of the glaze, and the intensity of the pigment in the solid color.

When working on a white ground, the glazes can be built up like watercolor. But few artists work entirely in oil glazes since each coat of paint must be dry before applying the next. Glazes are best used in conjunction with other techniques such as underpainting, scumbling, and impasto. Some artists like to stain parts of the canvas with a wash of dilute color, in contrast to passages in the same painting that are built up with impasto. It is a matter for experiment to determine the right approach.

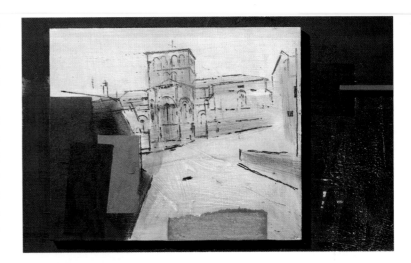

ABOVE *In this mixed-media painting of a Spanish church, dilute oil paint has been stained over the drawn detail with a soft rag to produce a transparent film of color.*

LEFT *The rich colors of rusting plate iron on a freight wagon provided the inspiration for this painting, which combines collage with broad brush-strokes of "dry" color.*

BELOW *A medium filbert is used to produce a dilute stain of color.*

Underpainting and Underdrawing

Underpainting is the preliminary drawing made in a single color directly onto the canvas or board. All the fundamental problems of drawing, composition, and tone are sorted out at this stage, leaving the artist free to deal with color values.

It is, of course, perfectly possible to begin working without any kind of underdrawing or underpainting – given that you have a good sense of design, you could start working right away in terms of color masses and tonal contrast. Much depends on the kind of subject you are painting. If, for instance, you are confronted by a coastal scene or landscape, where everything is distributed in terms of simple interlocking shapes, then it might make sense to begin working in blocks of color, and to leave any finer delineation that may be necessary to a later stage in the development of the painting. If, on the other hand, you are dealing with a subject of greater complexity, you might feel more confident by starting with an underdrawing, or an underpainting.

From my own experience, I find it useful to have some kind of underlying framework or "scaffolding" to build on so that additional corrections can easily be made during the early stages. The underlying linear structure of a painting can be carried out on a primed support with a soft pencil or charcoal. Such a drawing, however, will not be an integral part of the finished painting, since it will be canceled out by the first layer of paint.

UNDERDRAWING WITH CHARCOAL

Working with charcoal allows a complete gestural freedom, and the broad character of the medium prevents you from becoming too absorbed in fine detail. Corrections can be made by simply

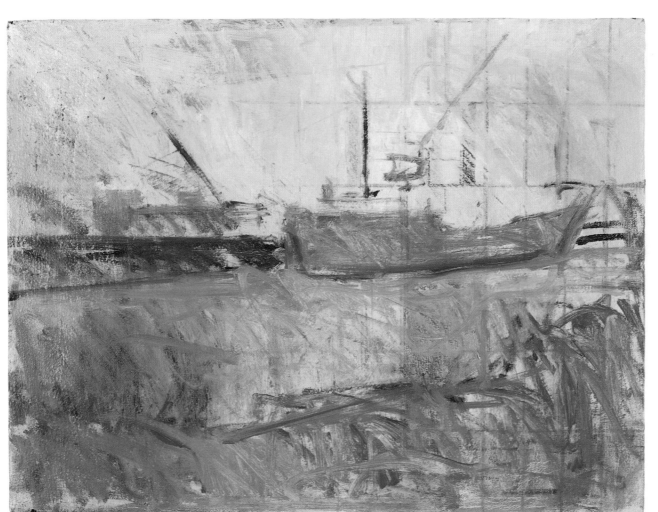

LEFT *This lively underpainting harnesses all the vital elements of the composition together. The successful development of the painting will depend on the balance of color and tone.*

OPPOSITE, RIGHT *Drawing of Zanora Cathedral, Spain, in pencil made from direct observation.*

OPPOSITE, FAR RIGHT *The drawing is used as reference to produce an underpainting in dilute Burnt Sienna on canvas paper.*

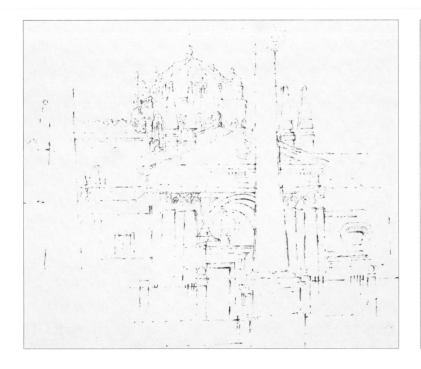

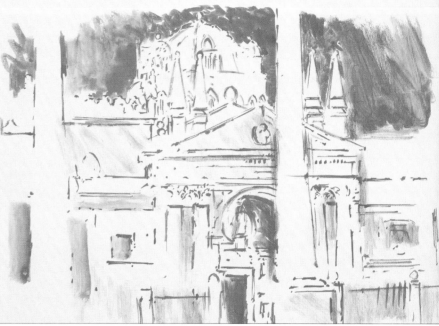

wiping the pigment with a soft rag or finger. Excessive pigment can be removed by tapping the support. It is advisable to fix the drawing before painting. Not only will the charcoal make dirty a pale color, but it is also disconcerting to work on top of a drawing which is unstable.

"I have now reached the point at which I have decided no longer to begin a painting with a charcoal sketch. It leads to nothing; one should attack a drawing directly with color in order to draw well," noted van Gogh, in a letter to his brother Theo in September, 1888.

UNDERPAINTING WITH A BRUSH

Many artists much prefer to start working with a brush. The paint is normally a thin glaze of a neutral color such as Sepia, Ocher or pale blue. If you intend working over the underpainting with further glazes, then the underpainting should be applied more thickly. Jan van Eyck always started with an underpainting as a thin wash of color, whereas Titian and Paolo Veronese did their underpaintings with thick pigment before overpainting with glazes.

For my own part, I find that often the first half-hour spent on an underpainting is the most satisfying aspect of the whole procedure. It is at this stage when everything is open and nothing is resolved, that I am most optimistic! I usually produce the underpainting with oil paint thinned with turpentine substitute.

If you are working on the colored ground of a previously stained canvas, it is as well to lay-in the underpainting in a darker strength of the color used for staining. I always try to produce paintings where part of the underpainting is exposed in the final painting – the alternation of transparency with opacity is, to my mind, one of the most interesting qualities of the medium. It is impossible, for example, to look at a painting by Degas, without being aware of the fact that the underpainting is an integral part of the finished painting.

The Venetians produced underpaintings in a range of warm and cool colors, to establish all the undertones before beginning the final painting. French eighteenth-century painters used a technique known as *grisaille*, a kind of monochromatic underpainting in tones of gray that show through as a middle tone.

Painting *Alla Prima*

32

*A*lla Prima comes from the Italian, meaning "at first." When we talk of a painting that has been produced *alla prima*, we are describing the technique of completing the picture in one session. This method of painting has been popular since the nineteenth century and coincided with the fashion for painters to venture out of the studio to paint directly from nature.

It is a way of working that reached its apotheosis with the French Impressionists, who made it a basic tenet of their painting philosophy. There may be a number of practical reasons why a painting must be completed in one session – the model sitting for a portrait may not be available for a second sitting, or you might have only a few hours to paint a particular landscape view.

To paint a subject *alla prima*, then, is to respond to your first impression – and in doing so, the painting is likely to be far more spontaneous and authentic than a painting produced from reference in a studio. We know that the authenticity of Cézanne's landscape paintings was due to his direct contact with nature. It is this aspect of painting that has most appeal for those who feel at one with their subject – when confronted by the actual experience of real fields, hills, valleys, rivers, and oceans. There is also something to be said for the idea of producing a portrait or life study in a single sitting; a rapid and direct response can often be more telling than a painting that has been labored over numerous sittings. The whole process of painting *alla prima* is of course rather "hit or miss" and it can go disastrously wrong, but when things do go well the results are particularly rewarding.

RIGHT *This small portrait was painted in one short sitting of about an hour.* BELOW *Life study produced in a single sitting of two hours. The painting technique combines washes of oil paint with a heavier impasto.* FAR RIGHT *This garden scene was hurriedly painted between showers of rain in about three hours.*

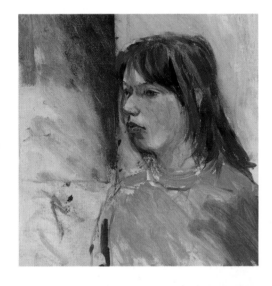

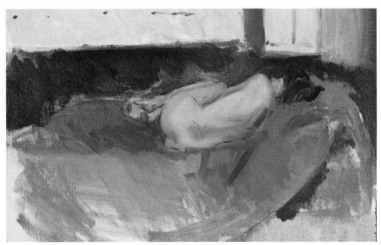

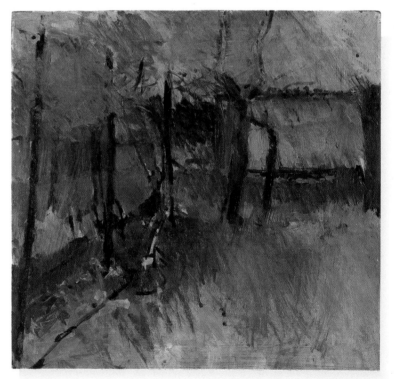

Wet-in-Wet

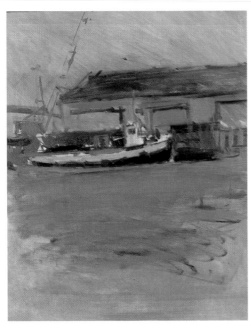

LEFT *Working boats tend to move from one berth to another without warning. This painting on board was rapidly executed in one sitting of 45 minutes in a failing light.* BELOW *This study of a farm wood-store was painted directly onto a small canvas as a single statement.* BELOW, RIGHT *This small life study was produced in a single sitting at a two-hour life class.*

Anyone producing an *alla prima* painting must of necessity work wet-in-wet; provided that the pigment can be kept moist, it is not necessary to complete the painting in one session. The drying times of oil paints are such that you apply fresh moist color into, on top of, and alongside existing wet color.

It is not a technique that allows for precise linear detail since the merging and blending of color tends to soften outlines. It is, of course, possible to vary the consistency of the paint, but you need to think in terms of broad blocks of color rather than sharply delineated forms. It is difficult to correct color values when working wet-in-wet; it is sometimes necessary to scrape off the color with a palette knife, before reworking a particular passage of the painting. Alternatively, if the impasto is too thick, you can try blotting off the surface with paper towels.

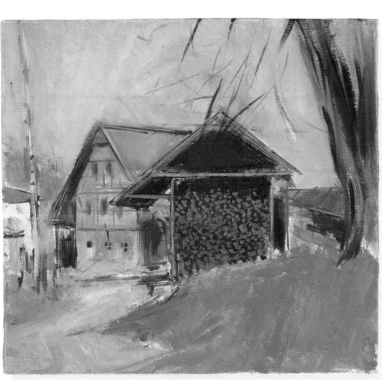

Color

34

In the course of teaching art students over the last 30 years, I have on occasion found that certain individuals do possess a kind of intuitive color sense. Most of us, however, must necessarily learn the hard way – through seeing, understanding, and experiencing. In my view, a complete and thorough understanding of color accrues gradually over the years, and is not something that can be acquired by reading a few books on color theory. A proper understanding of color theory is of course important, but my own appreciation of color has been achieved primarily by painting directly from nature and by studying the work of master colorists such as Titian, Jean-Baptiste Corot, Turner, Delacroix, Claude Monet, Jean Vuillard, James Abbotte McNeill Whistler, Gwen John and others. Moreover, I have become increasingly aware of the fact that color is always interpretative and, as such, dependent on the individual's emotional response to the subject at the time of painting.

We know from the experiments of Isaac Newton (1642–1727) that a ray of sunlight passing through a prism produces seven colored rays: violet, indigo, blue, green, yellow, orange, and red. We call this the spectrum, and we see color in objects that reflect or absorb these rays to a greater or lesser extent. If, for example, white light – which is a mixture of all the colors of the spectrum – is shining directly onto a flat surface that is red, it will reflect mainly red. If, on the other hand, the light falls onto a red ball or apple, which is three-dimensional, it will reflect a variety of other colors as the light is deflected by the curvature of the form. The area of shadow might be tinged with blue or violet.

Color exists only in relation to other colors. Bright primary colors, for instance, can change the value of a dull opaque color, simply by being placed in juxtaposition. We call this phenomenon "simultaneous contrast." For this reason, the colors we use in painting must always be considered in relation to one another.

PRIMARY COLORS

The three primary pigment colors are red, yellow, and blue. They are called "primary" colors because it is not possible to mix them from other colors on the palette, and they are also the base colors for secondary and tertiary colors.

ABOVE *A color wheel of softly merging primary, secondary, and tertiary colors.*

SECONDARY AND TERTIARY COLORS

Secondary colors are those mixed from the three primaries: orange from red and yellow, green from yellow and blue, and violet from red and blue.

Tertiary colors are produced by adding proportionally larger amounts of one primary color to another.

COMPLEMENTARY COLORS

The colors that appear opposite each other on the color wheel are known as "complementary colors." The complementary color of each of the primaries, for instance, is a mixture of the remaining two primaries. Thus green (blue and yellow) is the complementary color of red, blue is the complementary color of orange (red and yellow) and yellow is the complementary color of violet (red and blue).

Complementary colors are contrasted from light to dark, and from warm to cool. If they are mixed together, however, they cancel each other out – turning to gray or near black.

RIGHT *A color exercise exploring complementary color contrasts.*

Contrast and Harmony in Color

There are basically two ways of achieving color harmony in a painting. First, by using closely related colors, that is to say, colors that are found together on the color circle. A landscape, for instance, might be painted in a harmony of ochers, siennas, and chromes. Second, harmony can be attained by carefully contrasting complementaries. Turner, for example, often used to create very subtle harmonies of warm and cool colors in his paintings of landscapes and seascapes.

There is a small painted panel by Walter Sickert called *The Red Shop* that I like very much. It is a painting of a shop in Dieppe. The shopfront itself is painted in a brilliant shade of Vermilion, but the color is given much greater intensity by the surrounding drab ochers, brown and Umber.

A bright color produces an after-image of its complementary, which will affect colors seen in juxtaposition. Colors cannot be considered in isolation, and you must be constantly making adjustments to both color and tonality, as part of the painting process.

A painting that has little or no contrast can often appear flat and dull. The contrast may be very subtle, as in the work of Vuillard, for instance. Conversely, the contrasts can be extremely violent as we see in certain paintings by van Gogh or in Fauvist paintings such as those by Matisse. Cézanne used contrasts to give his painting greater vibrancy – the repetitive strokes of green that represent the needles of umbrella pines seem to be in continuous movement against the contours of the land mass and sky. When artists talk about the quality of the light they are not only

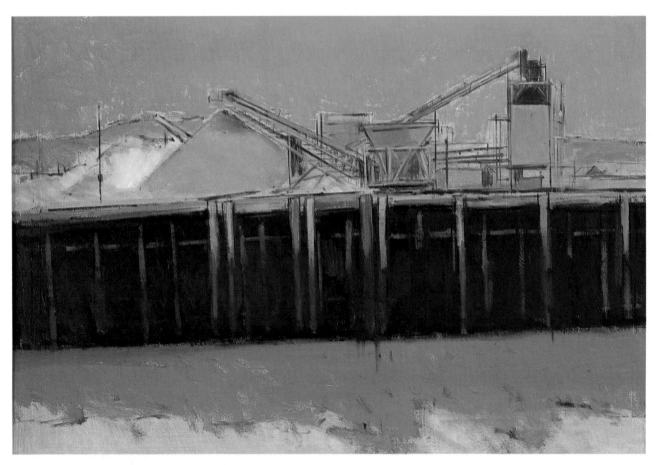

LEFT *Contrasting complementary colors used to heighten the underlying abstract elements of the composition.* OPPOSITE, TOP RIGHT *A successful harmony of color and tone.* OPPOSITE, FAR RIGHT *A study of Vuillard's,* The Kitchen, Boulevard Malesherbes, *produced to see how the artist used a limited palette of closely-related colors.* OPPOSITE, BOTTOM RIGHT *A harmonious relationship of mid-tones and colors of neutral density creates a pervading calm.*

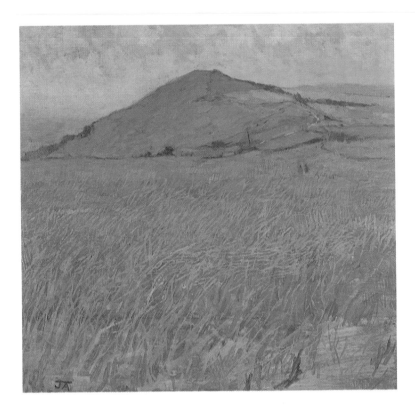

referring to the clear bright atmosphere of a sunny day! They are concerned with the way that certain conditions of light enable them to see scales of color and tone that they must try to capture to produce contrast and harmony in their paintings.

The seeming complexity of contrast and color will become less bewildering with practice – not just in the handling of materials and techniques, but also when searching for suitable subjects to paint. You have to learn to look with these things in mind.

In the small working port of Newhaven, on the south coast of England, a few miles from where I live, I can always be sure that if I walk from the Customs House to the harbor entrance, I will find a series of subjects that are sufficiently stimulating in terms of contrast and color. The fishing trawlers painted in bright primary colors contrast with the darker tones of the sludge-covered landing stages and the surrounding murky water.

The important thing is to allow yourself to be open to possibilities, and to respond before the sensation fades.

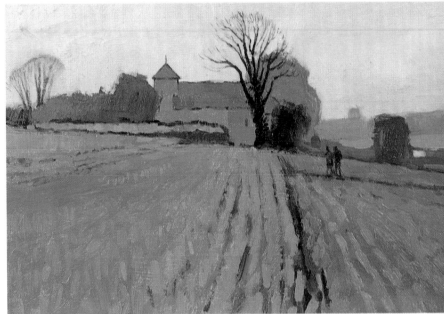

Color Exercises

The following exercises might prove useful in helping you to understand the problems of contrast and color, and also ensure that you get into the habit of mixing colors thoroughly with a sense of purpose.

Allow plenty of space for mixing color. If you do not have a large palette, use a slab of glass on a table. Practice blending colors together thoroughly using a palette knife.

❶ *Paint a roughly defined square or rectangle of orange-red on a white ground. Add secondary and tertiary complementary colors as adjacent shapes, working in a purely abstract way so that the first color is isolated.*

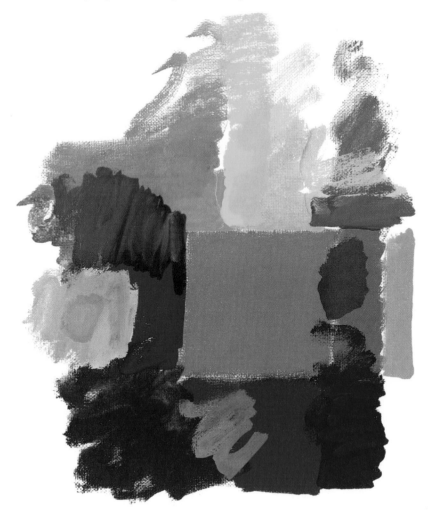

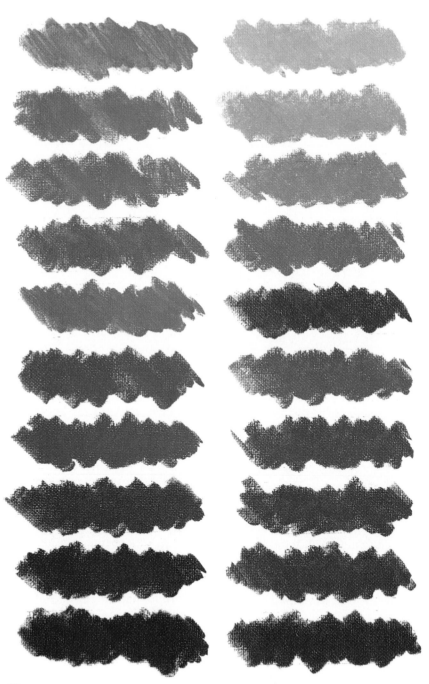

❷ *Mix ten cool grays and ten warm grays arranged as two parallel tonal scales. Make notes of the colors used and keep for future reference.*

③ *See how many objects you can find around the house that are all the same color but of differing shades and hues. Anything will do – books, items of clothing, fruit and vegetables, ornaments, crockery, and so on. Arrange everything in terms of overlapping shapes. Now produce a painting that reduces everything in your arrangement to basic abstract colored shapes. Make sure that you match colors carefully in terms of intensity and contrast.*

A grouping of objects selected at random for their color value.

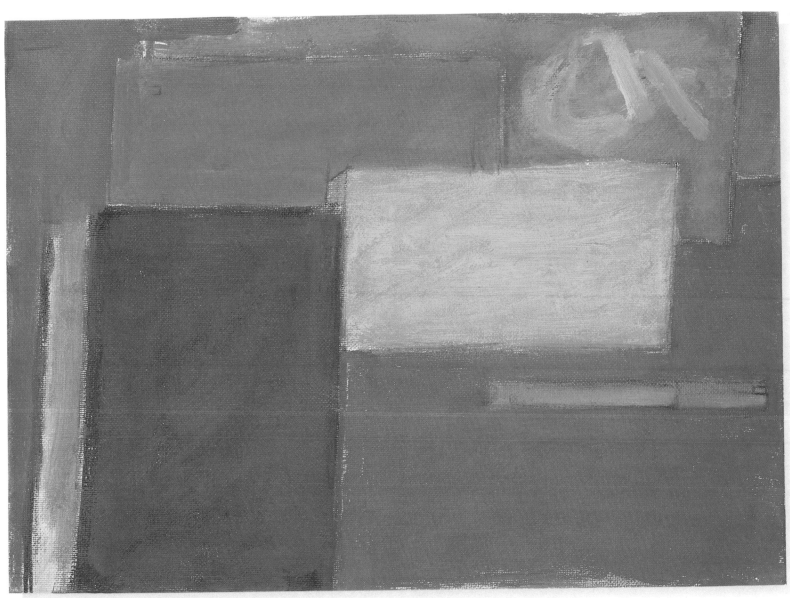

Tone

When you look at great paintings by masters such as Rembrandt, Nicolas Poussin, or Turner, you become aware that everything in their composition is related to an overall tonal theme. It is usually the case that people who paint badly often have difficulties with tone; it is the tonal qualities that pull the colors in a painting together. For this reason, it is important to understand how tonal values work. If the tone of a color has been badly judged, the color itself will look wrong – poor color values can usually be attributed to a lack of tonal unity.

By tone we mean the degree of lightness or darkness of a given color. Although black and white are not colors – they represent the extremes of the tonal scale.

The French chemist Michel Eugène Chevreul, in his experiments to produce modified tones, reached 14,440 tones that are measurable. It is important to distinguish between the tone of the actual color of an object (the local color), and the tone produced when that same color is modified by light. Visually, tones are affected by shape, texture, and local color, as well as by distance, and by the quality of light.

Colors that are of a different hue might have the same tonal value, so you must give careful consideration to the particular balance of light and dark shapes in painting. In practice, colors will either advance or recede when modified by being made lighter or darker, warmer or cooler.

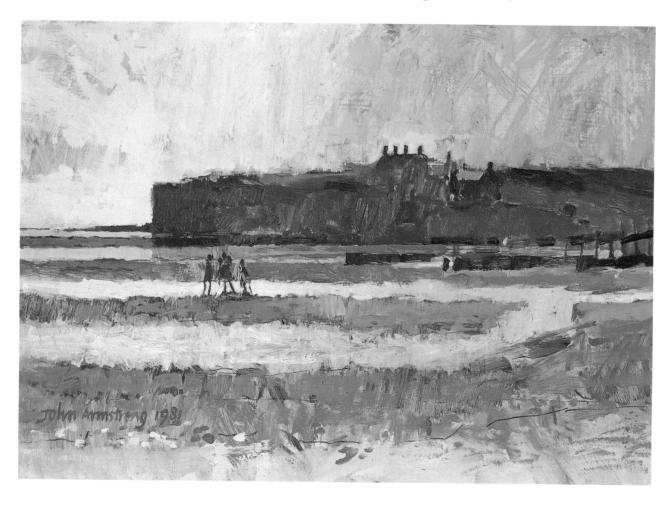

The artist has produced a harmony of warm and cool grays in this study of Cuckmere Haven in Sussex, England. Tonal contrasts are clearly defined – the dark headland is seen against a pale sky, and alternating passages of light and dark planes suggest recession on the seashore.

LEFT *A tonal exercise using cut and torn paper overpainted with scumbled color.*

RIGHT *This painting of an avenue of stones on the ancient site of Olympia in Greece, demonstrates how basic forms are defined by light, color, and tone.*

BELOW *A turbulent sea is represented as a series of interlocking warm and cool tonal planes.*

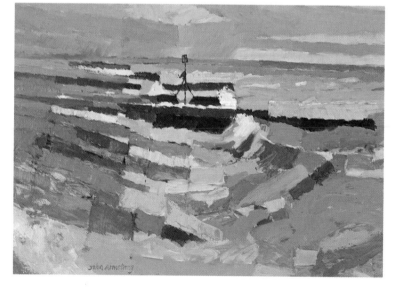

As an exercise in tonal control, try setting up a still life with a selection of brightly colored objects against a background paper that is one of the three primaries. Produce a painting of the still life, using only the warm or cool grays that were mixed for the previous color exercise (see page 38–9). The main purpose of this exercise is to raise a number of basic questions about the exact relationship between perception and painting. Is it possible, for instance, to register the outline of an object seen against a background of the same tone? How can you represent what you see in reality within the limited range of tones at your disposal? How does light affect tone?

If you do attempt this exercise, you might find that you are more than pleasantly surprised by the results and, more important, you will have a much better understanding of tonal values in painting.

Composition

42

The French poet Paul Valéry felt that there were two essential qualities to be found in a work of art: analysis and music. Painters, too, often talk about trying to reconcile the opposing forces of freedom and order in their work. Robert Medley once said that there were two sides to his pictures: the baroque and the austere. As he observed, "I've always found it difficult to reconcile these two extremes. This I suppose is what kept me going."

Composition – the ordering of elements in a painting – can sometimes start long before any paint has been applied to the canvas. When, for instance, I am searching for a new subject to paint, I am consciously or unconsciously also examining the compositional possibilities. That is particularly true when I am looking for a landscape subject. Landscape is indeterminate, and you select a particular viewpoint because, within the parameters of that view, you are somehow moved or excited by the disposition of elements – trees, rivers, fields, hills, and so on.

Having found a suitable subject, you must also take account of the dimensions of the canvas or support in terms of the composition. Matisse once said that his drawings were always related to the given dimensions of the paper, and that he would not repeat the same drawing on a sheet of paper of a different size. Some painters – Alberto Giacometti for instance – began by painting a loosely defined frame within the canvas area.

All good paintings, no matter how indiscriminate they may seem, are based on an underlying, carefully composed structure. Every element in the painting must count, even though there may be differences of emphasis. The space between objects in a still life, for example, is just as necessary as the objects themselves.

But composition should not be thought of as a convenient means of fitting everything into a preordained plan. Delacroix described composition as the organization of analogies, taking account of lines, shapes, color, contrast, tone, rhythm, and movement.

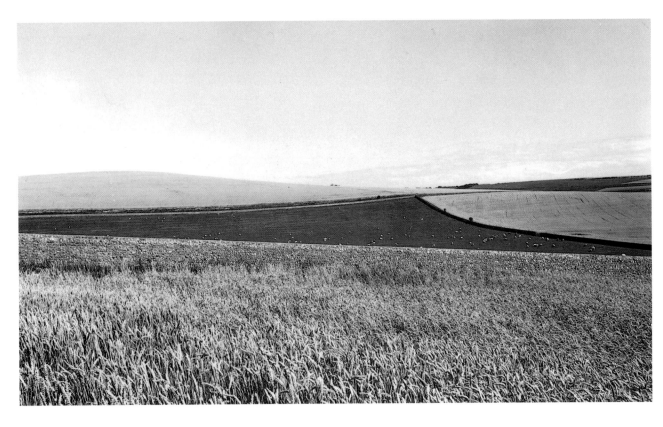

As an exercise in composition, a photograph was taken of a field of sheep surrounded by low flint walls. It was framed to show particularly strong shapes.

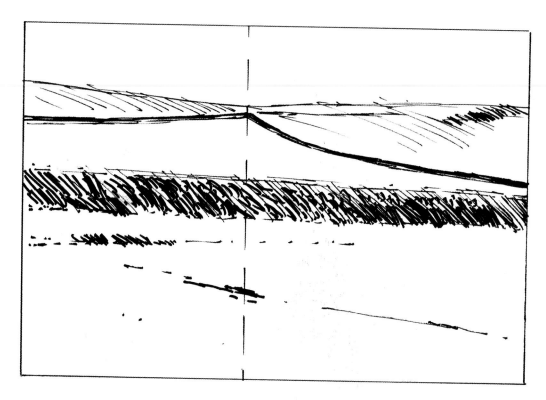

LEFT *A sketch was made from the photograph suppressing detail and reducing the scene to its basic compositional elements.*

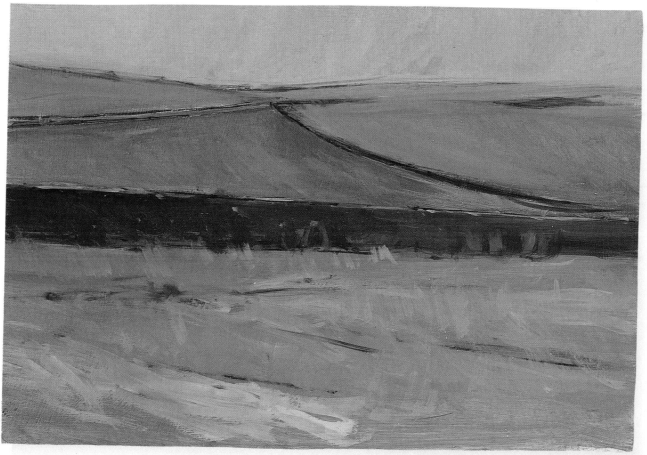

LEFT *A painting was made on site using the sketch as a guide. The emphasis is on the underlying geometry of the composition.*

Scale and Proportion

44

There are a number of simple devices for dividing the picture plane that have been used by painters since the Renaissance. The best known of these divisions is called the Golden Section. The basic premise of the Golden Section is that the proportion of the smaller to the larger is the same as that of the larger is to the whole.

The Fibonacci Series is another method of establishing related proportions, based on the idea that each succeeding number is the sum of the two preceding numbers, i.e., 1.1.2.3.5.8.13.21 and so on. Examples of its use can be found in the work of Piero della Francesca and other Renaissance masters.

LEARNING FROM THE MASTERS

One can gain a much better understanding of composition by making transcriptions from master painters such as Piero della Francesca, Poussin, Jan Vermeer, Pieter de Hooch and Georges Seurat. In the study of Vermeer's painting, *Young Woman In Blue* (1662–64, 21 x 19 inches), I began by marking the exact dimensions of the original, onto a primed piece of plywood 23 x 24 inches, thus allowing a border all round the image. Because I was working from a reproduction that had been scaled down to half size, I had to make the necessary adjustment in my preliminary measurements to get back to the size of the original painting. Working in a soft pencil, I first noted the essential divisions of the picture-plane. When working on a transcription of this kind, you are concerned not with simply making a copy of the painting, but rather with trying to uncover through analysis how it was constructed.

The underpainting was done in a bister of Sepia. As the work progressed I became very conscious of Vermeer's superb sense

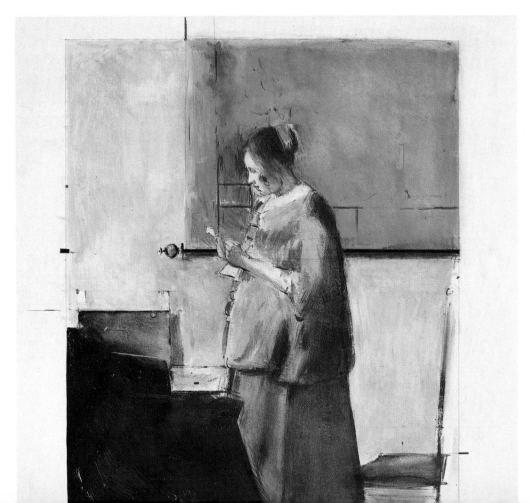

LEFT *Transcriptions from Vermeer's* Young Woman in Blue. *The first study is the same size as the original.*
ABOVE *The second study attempts to uncover the relationship between the standing figure and the background.*
OPPOSITE *Transcription from Vermeer's* A Woman Weighing Gold *adapting the proportions to a square canvas.*

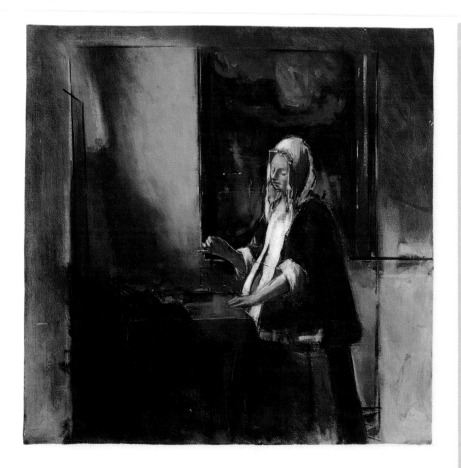

of composition – the exquisite placement and how every element was related to an underlying abstract structure. I became very aware of the negative shapes between objects – the subtle shape created between the back of the figure and the chair on the extreme right, for example. The particular angle of the head is based on a diagonal line that runs from the bottom left-hand corner to a point that marks the Golden Section.

The second study, *A Woman Weighing Gold* (1662–64, 17 x 14 inches), was painted onto a square canvas of a different proportion to the original. Here, I was concerned more with extracting the main elements than with making a precise transcription. The woman holding a balance in her right hand maintains her own posture by touching the table with her left hand.

THE GOLDEN SECTION

To divide a rectangle using the Golden Section theory, start with a square ABCD. Divide the square in half with line YX. Place a compass point on X and, using B as a radius, describe an arc cutting the extension of line DC at E. Raise an upright from E to meet the extension of the line AB at F. The Golden Section rectangle is AFED. The line BC indicates the Golden Section division.

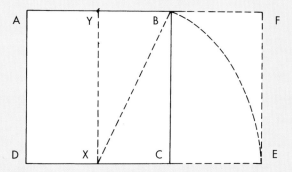

A simple formula can be used to discover the Golden Section point on any line. Take the line AB and raise an upright from it, BD, which is equal to half the distance from A to B. (The point C on AB indicates the halfway point.) Draw a line to join A to D.

Now, place a compass point on D and, using B as a radius, describe an arc from B to cut AD at X. Next, place the compass point on A and, using X as a radius, describe another arc to cut AB at GS. This is the Golden Section point.

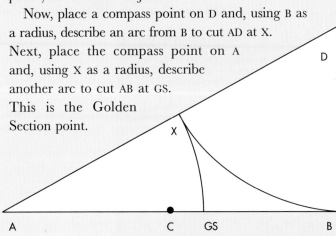

Rhythm and Movement

ABOVE, LEFT *Tourists hurrying through the Eygptian galleries of the British Museum seem insignificant in relation to the sculpture.*
LEFT *This painting attempts to arrest the movements of the conductor Christof Penderecki.*

Our perception of the world has changed dramatically in the latter part of the twentieth century. More often than not our experience of landscape is a fleeting glance from the window of a car or train traveling at high speed. But more than that, the whole pace of life has changed to such an extent that we tend to scan rapidly rather than pause for any length of time. And yet, all of our sensory experience comes from movement – without movement there is no life. In drawing and painting, we use line to express movement because line transports the eye more rapidly than blocks of color or flat shapes. The futurist painters, led by the Italian Umberto Boccioni, attempted to render movement in their paintings with unequal success. In their manifesto of 1910, they proclaimed, "Universal dynamism must be rendered in painting as a dynamic sensation . . . motion and light destroy the materiality of bodies."

It is difficult to take account of movement while painting from direct observation – and nature is never still, everything is in constant movement, however imperceptible. Horizontal and vertical lines can be used to give an air of stability. Diagonals, because they are off balance, are symbols of motion and suggest continual movement.

I have recently been working on a series of paintings based on the Egyptian Rooms at the British Museum in London. I was interested in the visual dichotomy between the stillness and monumentality of the wonderful artifacts, and the movement of groups of tourists hurrying past. I made some rapid sketches, and also took some reference photographs using a fast shutter speed to arrest the movement. From the drawings and color prints I was able to reconstruct the image on canvas, starting with an underpainting in Sepia.

Some marks were lost and others gained, and it was important to maintain the balance between stillness and movement. It is always easier to start a painting than to know when it is finished. I sometimes leave a painting around for a month or so until I am sure there is nothing to be added or taken away. Sometimes it is a case of making a particular tone lighter or darker. On occasion I have been known to take the most drastic of moves and have started a painting again.

LEFT *Because musicians are constantly moving, the artist must react by making rapid judgments visually.* BELOW LEFT *There is an interesting relationship in this painting between the static form of the scuplture and the blurred figure in movement.*

BELOW RIGHT *The vertical structure of walls and pillars provide visual equivalents to the single moving figure.*

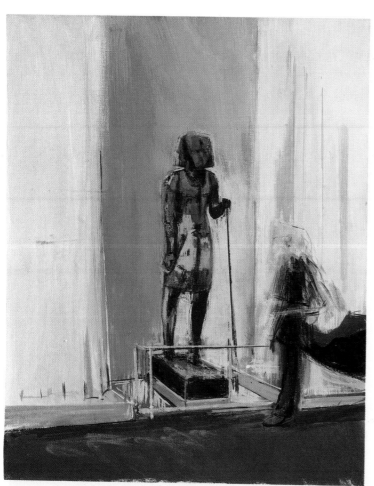

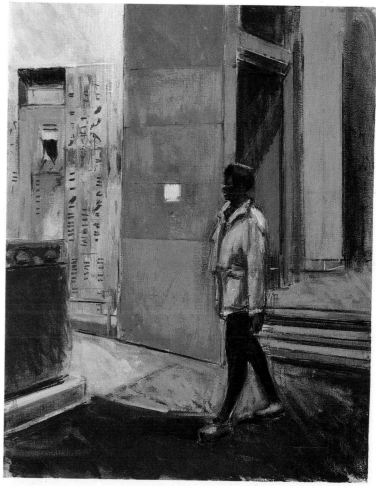

Form and Structure

When we talk about structure in painting, we refer both to the underlying organization of space, using divisions such as the Golden Section, and to the visible elements of the painting concerned with substance and stability. "Construction," said the poet Charles Baudelaire, "is the framework, so to speak, the surest guarantee of the mysterious life of the works of the mind."

I have always been interested in the way that artifacts and architectural structures can add dynamism to an otherwise dull scene. On most days, if I walk down to the seafront where I live, I can watch the wooden structures called "groins" being bolted together from rough-cut planks of wood. The groins provide stability, preventing the shingle beach from being shifted away by the tides. The artist is ruled by what he or she sees, and while, as a conservationist, you might object to a structure such as an electric pylon being placed in a landscape, as an artist, you might find that such a structure provides the essential link to your composition. I find that industrial landscapes often take on a grandeur that is missing in more conventional landscape subjects. I am interested both in the structural aspect of composition theory, and subjects that combine artificial structures with natural forms.

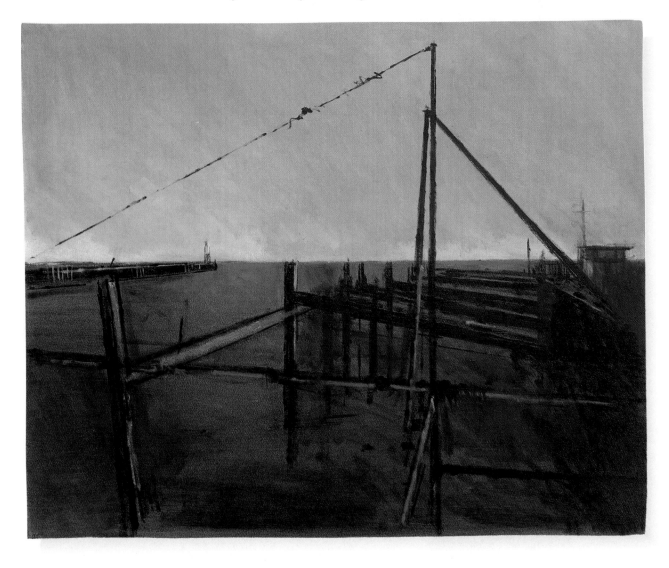

LEFT *The wooden structures of the entrance to Newhaven harbor in Sussex, England define the space of ocean and sky.*

OPPOSITE RIGHT *Industrial artifacts, such as this sand and gravel hopper, can often provide more visual interest than conventional landscape subjects.*

RIGHT *In this painting a steel cable revealed at low tide provides a visual link that the eye follows from the foreground to the boats in the middle-distance.*

BELOW RIGHT *The structural elements in this industrial harbor scene have been carefully selected to produce an interesting composition.*

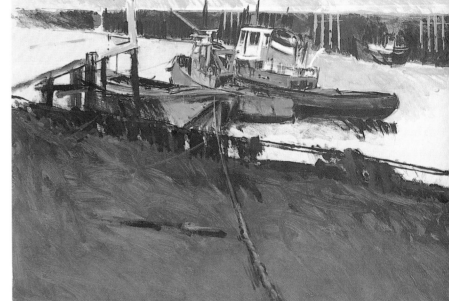

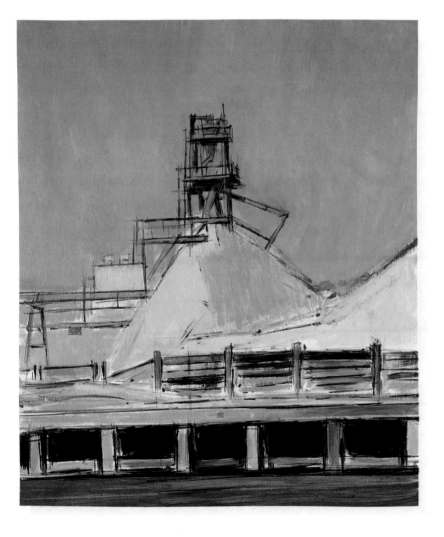

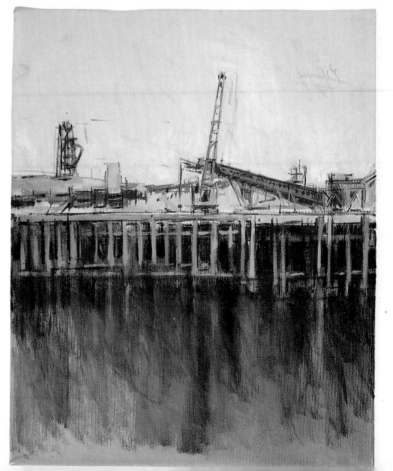

Perspective

50

Perspective is the means by which we suggest distance and three dimensions in painting. There are a number of different perspective systems, the most important of which for the painter is aerial perspective. Aerial perspective makes use of the gradation of colors to suggest distance. In the wonderfully atmospheric landscapes by Turner, for instance, we see how subdued color and forms, which are less distinct, lead the eye toward cooler and lighter tints, and perhaps the barely perceptible form of a church or castle on a hillside. Leonardo da Vinci in his notebooks referred to the phenomenon of aerial perspective: "You know that in an atmosphere of uniform density the most distant things seen through it, such as the mountains, in consequence of the greater quantity of atmosphere which is between your eye and them, will appear blue, almost of the same color as the atmosphere when the sun is in the east." He goes on to say that buildings in the foreground should be painted their natural color, and those more distant "less defined and bluer."

Linear perspective is often used together with aerial perspective. The Renaissance architects Filippo Brunelleschi and Leon Battista Alberti are credited with its invention, and it formed the basis of paintings by Piero della Francesca and Luca Signorelli.

Linear perspective is based on the premise that all lines in nature appear to converge as they recede from the spectator and meet at a point on the horizon we call the "vanishing point." The eye is on a level with the horizon and, as a consequence, lines that move away from the spectator and are below the eye-level, will move upward toward the horizon. Lines above the eye-level move in a downward direction to the horizon. In more complex arrangements of perspective, there are multiple vanishing points. All perspective systems are a distortion of visual perception, because we do not see everything on a flat surface.

THE PICTURE-PLANE

The picture-plane is an imaginary transparent vertical plane set on the ground, and is at that distance from the artist where the painting begins. The artist's exact position behind the picture plane is critical, and when people experience things going wrong, it usually has something to do with the eye-level.

If, for instance, you are sitting on the ground, the eye-level will be radically different than if you were standing. Again, if you move to the extreme right or left of the picture-plane, there will be a corresponding shift in terms of perspective.

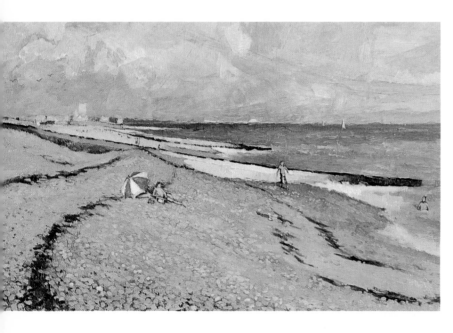

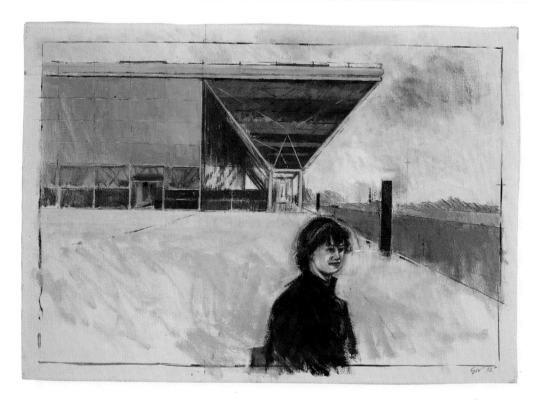

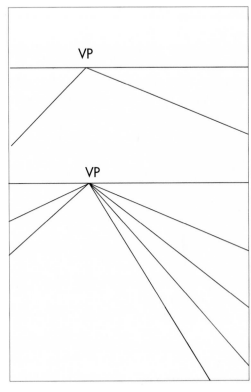

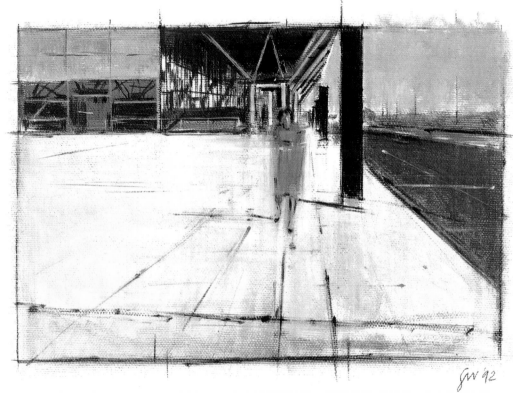

OPPOSITE *In this seascape and landscape, aerial perspective has been employed by adjusting color and tonal values to suggest recession and distance.*

ABOVE *These two diagrams show how lines that are parallel to each other seem to converge at the vanishing point VP.*

LEFT *The use of linear perspective is evident in these two paintings of Stansted Airport, England. The inclusion of a single figure in the compositions provides an added sense of scale.*

Painting from Drawing

52

There are painters who subscribe to the view that one's work should be carried out in the presence of the subject or motif – what we commonly call "painting from nature." There is a lot to commend this point of view; spontaneity and purity of vision are among the qualities we associate with painting directly from the subject. But as Walter Sickert once said, "Do you suppose that nature is going to sit still and wait until you have got what is there?" He reinforces his argument by suggesting that all interesting things that happen in nature are anyway of momentary significance. He cites the fact that Jean François Millet made notes on scraps of paper while watching people working in the fields. Very few paintings are literal transcripts from nature, and some of the greatest masterpieces were produced by a combination of memory, imagination, and varying sources of reference.

The drawings produced as reference for painting are not intended for exhibition. They are, however, of great interest because they show the working of the artist's mind – the first thoughts on the subject. What matters most is that your drawing should have sufficient information for you to be able to develop your painting with conviction. Some artists like to add notes to the drawing to remind themselves of color values. Thus one might find descriptions such as "mid-slate," "buff," or "brick red" added as footnotes.

Remember that you will have to interpret your drawing in a much broader way with a brush. Most reference drawings are produced "sight-size" – the scale to which you draw naturally, depending on your distance from the subject. That means that the drawing will have to be enlarged in proportion to the size of the canvas or board.

SQUARING UP

It is important that the proportion of the drawing and canvas are the same. A drawing on a piece of paper sized $9^{1}/_{3}$ x $11^{1}/_{5}$ inches, for example, is in direct proportion at a ratio of 2:5 to a canvas sized 24 x 28 inches. To check the proportion of the drawing against the canvas, draw a diagonal line on the drawing from the bottom left-hand corner to the top right-hand corner. Now draw a similar diagonal on the canvas and place the drawing to fit the bottom left-hand corner of the canvas. Lay a rule or straight-edge along the diagonal – if the top edge of the rule intersects the top right-hand corner of the canvas, it is in proportion.

A grid of squares is overlaid on the original drawing. The same number of squares are measured onto the canvas. It is then possible to match the content of each square of the drawing to the corresponding square on the canvas – so that the original

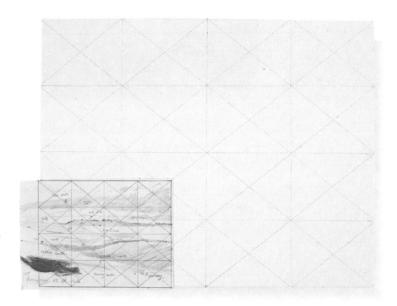

drawing is enlarged. The drawing on the canvas, resulting from this particular method of squaring up, will almost certainly look very stilted, but it will provide a firm basis for making a start on the underpainting.

SICKERT'S METHOD

Instead of scaling up the drawing onto canvas, Sickert preferred to use a thin sheet of paper the same size as the canvas. To transfer the drawing to canvas, he first painted some old newspaper with black oil paint. The painted side of the newspaper was placed in contact with the canvas, and the enlarged drawing placed on top. All the lines were then traced through with a hard pencil, which forced a deposit of the black pigment onto the canvas underneath it – in much the same way as carbon paper.

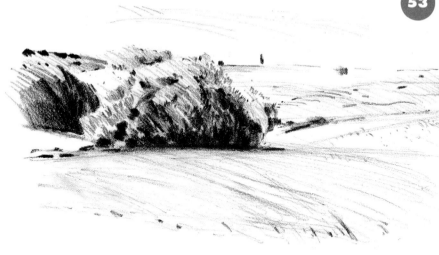

OPPOSITE FAR LEFT *A landscape drawing that has been squared-up prior to transferring to canvas.*

OPPOSITE LEFT *A landscape drawing has been divided by a grid of 16 squares. The corresponding squares are scaled up in direct proportion to the dimensions of the canvas.*

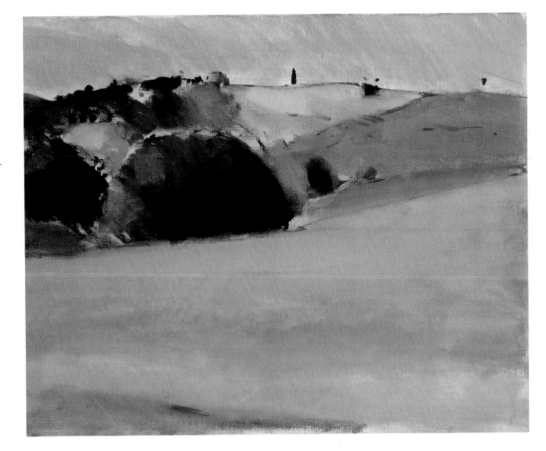

ABOVE *It sometimes happens that a landscape view seen momentarily on a journey can be drawn quickly and used later as reference for a painting.*

LEFT *This painting was made in the studio from the sketch, the artist having committed color to memory.*

Painting from Photographs

54

Despite the fact that artists of the caliber of Degas, Bonnard and Vuillard used photographs for their paintings in the early part of this century, many artists today remain skeptical about such a practice. There are, of course, obvious dangers in that the painting can be nothing more than a slavish copy of purely photographic values. Sickert, who also used photographs as reference, once suggested that, rather like alcohol, photography should be allowed only to those who can do without it!

Photographs are most useful as a stabilized source of reference. This is particularly important when we need to record a situation where, for instance, figures are in constant movement, or where one is working against time itself. The English artist Paul Nash (1889–1946), who was forced by illness to rely increasingly on photographic reference, also spoke of the "peculiar power of the camera to discover beauty." The viewfinder on a camera is in fact a very useful compositional aid.

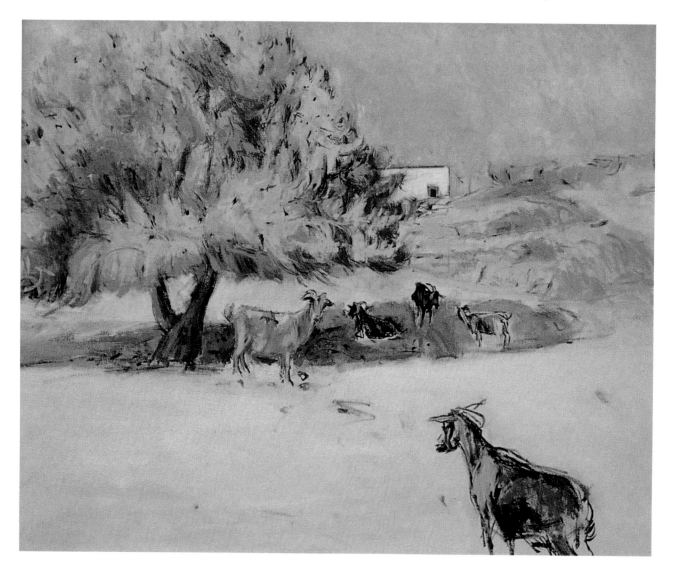

This painting of a goatherd was inspired by a visit to a small island near Patmos, Greece. A few rapid sketches and photographs were the only sources of reference. During the course of painting, radical adjustments were made to color and tone to produce a more brilliant suggestion of the light.

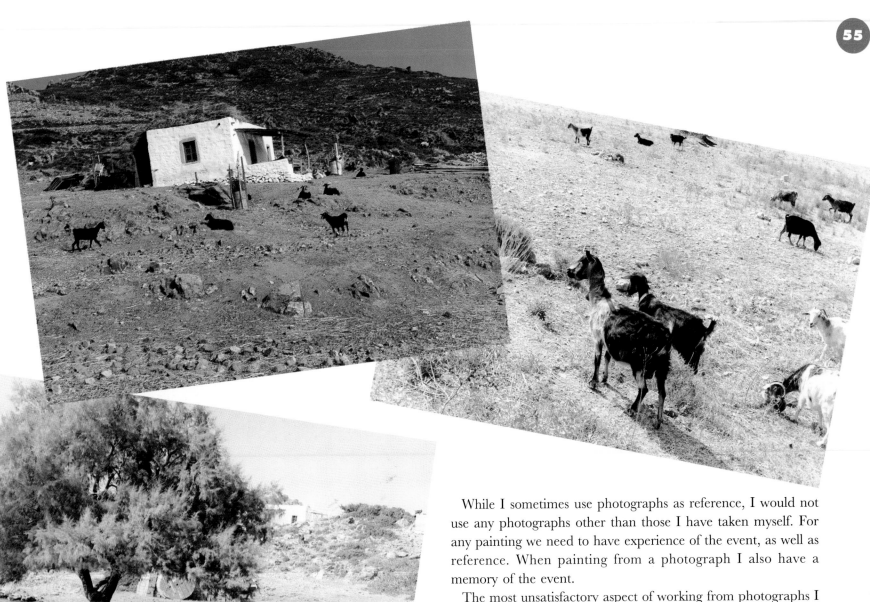

While I sometimes use photographs as reference, I would not use any photographs other than those I have taken myself. For any painting we need to have experience of the event, as well as reference. When painting from a photograph I also have a memory of the event.

The most unsatisfactory aspect of working from photographs I find, is that there is not enough information. I see more when working from direct observation than anything registered on photographic film. In addition, the color values are leveled out to such an extent that they are misleading. Another difference is that I would rarely add anything to a painting produced from direct observation, but I am constantly making adjustments to paintings produced from photographic reference.

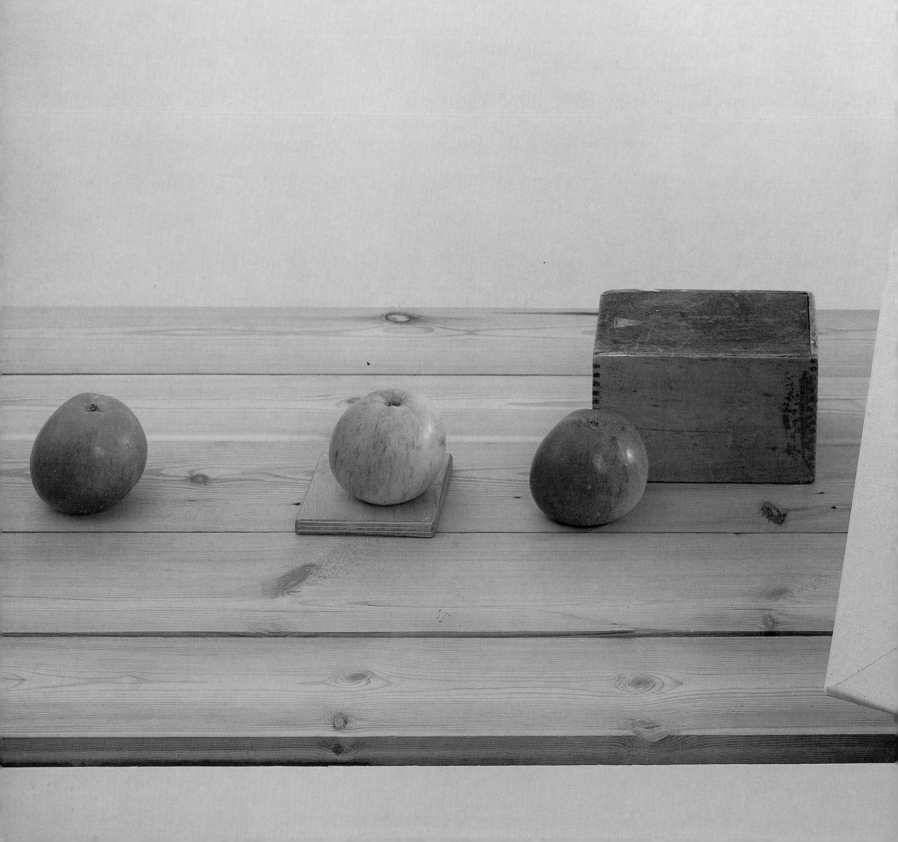

THE
PROJECTS

How the Projects Work

The first part of this book has dealt with the materials and techniques of oil painting. If we want to realize our subjects and to express our visual experience fully, we must necessarily be able to handle techniques confidently. If, however, we were to be concerned solely with achievement then our work would be completely devoid of imagination.

In the Project Section that follows, you will see how three artists have approached the same subjects in terms of their own personal visions and techniques.

The introduction to each of the ten projects attempts to identify the specific problems associated with each project, and suggests possible solutions.

By following the step-by-step progress of each artist you will see how each interprets the project in his or her own way. One artist might succeed in terms of color, for instance, but be let down by the composition. It is difficult to take account of everything. Sometimes our faults are not immediately apparent until we compare what we have done with the work of someone else who is tackling the same problem. When one of Whistler's pupils said, "I paint what I see," Whistler replied, "Indeed, but just you wait and see what you have painted!"

SOPHIE MASON is a born colorist as is evident in her handling of the series of projects that follow. She is best known for her landscape paintings and enjoys searching for new subjects. Her paintings of Spain demonstrate an acute awareness of the effects of light. She likes to combine a mixture of media in order to achieve the rich variety of color and texture that she uses so joyously in her work.

JOHN ARMSTRONG is an experienced painter with considerable knowledge of the craft of painting. He has made a particular study of the working methods of artists of the Italian Renaissance. This he has put to good use in his many commissions for altar pieces for churches in England. He enjoys drawing and painting directly from observation, however, and has recorded the English landscape in all seasons and under varying conditions of light.

Specially devised projects designed to cover popular subjects.

ROBERT WILLIAMS is an artist with a growing reputation for his landscapes of the chalkland areas of southern England. In addition, his professional work as a conservator of oil paintings has given him a completely unique insight into working methods and materials.

*Techniques and
methods explained clearly
and precisely with
easy-to-follow text.*

*Color palettes presented
with every project.*

*Clear step-by-step
photographs show the
artist at work.*

*Each project is
painted by three different
professional artists.*

*Inspiring "critique"
spreads compare different
approaches and
interpretations.*

*Practical problems
highlighted by
the author.*

*Helpful tips and advice
given by top professional
oil painters.*

*Results judged by the
author, based on sound
visual judgment and
practical good sense.*

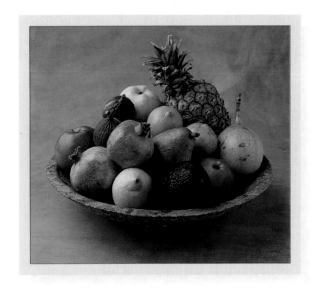

Still Life

BOWL OF FRUIT

A still-life group can be a carefully arranged selection of objects that are of particular interest to the artist, or a random collection of unrelated items thrown together in a haphazard way. Whatever objects you choose, and however they are arranged, try at least to select things that you like. If the still-life group holds no particular interest, then that will inevitably be reflected in the resulting painting.

A bowl of fruit is more than just the sum of parts – each apple or pear has its own individual shape and color. The success of the painting will depend on just how much you are prepared to invest in trying to uncover the specific values of each inanimate object and the collective values of color, tone, and composition.

The advantage of having everything in a fixed position for a number of days or weeks might be lost if you lose interest after a few hours. It is important, therefore, to determine from the outset what you want to get from the subject. You can pace yourself, for instance, by concentrating on the main structure during the first two sessions, before progressing to color values during third and fourth sessions. But this will be determined by the complexity of the subject, and the amount of concentrated effort that goes into trying to understand and evaluate the shape and structure of natural forms. Do not have too high an expectation of the finished result, but rather try to gain ground by looking at the subject freshly at the beginning of each session.

Artist • Robert Williams

VANDYKE BROWN

RAW SIENNA

NAPLES YELLOW

COBALT BLUE

VIRIDIAN

YELLOW OCHER

1 The ellipses of the bowl and the basic shape of the fruit are carefully drawn with graphite pencil on a primed board. The basic tonal pattern is restated on top of the existing drawing with Vandyke Brown using a No. 6 flat hog's hair brush.

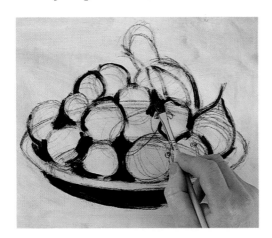

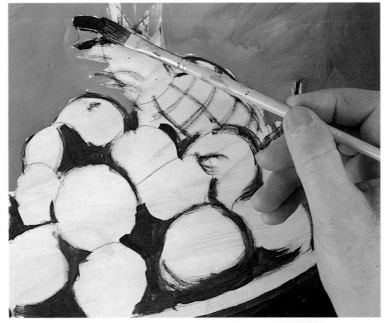

2 A neutral green mixed from Raw Sienna, Naples Yellow, Cobalt Blue and Flake White is blocked in to the background. The color and tone of the background is modified to a darker tone with a green based on Viridian.

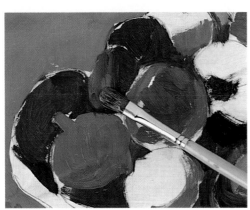

3 Individual fruits are given an undertone of brown and light red. Work continues on the basic colors of the fruit.

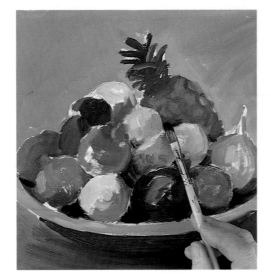

4 The rim of the bowl is painted in a pale tone of red where it catches the light. Yellow Ocher and pale green are added to the fruit.

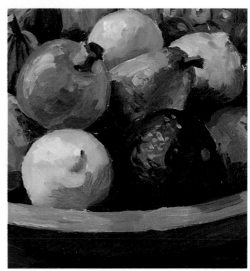

5 All the details and texture are added to the fruit, and the contrasting tones of the background and the bowl are further modified.

Artist • Sophie Mason

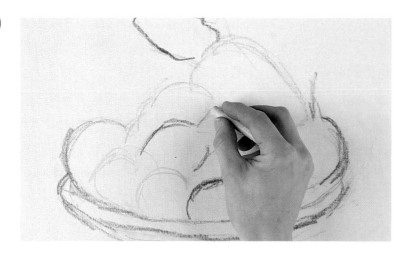

1 *The outline shapes of individual fruit and the bowl are loosely sketched in with oil pastels on primed canvas paper.*

2 *A thin glaze of Olive Green is laid over the whole area with a No. 10 short hog's hair flat brush.*

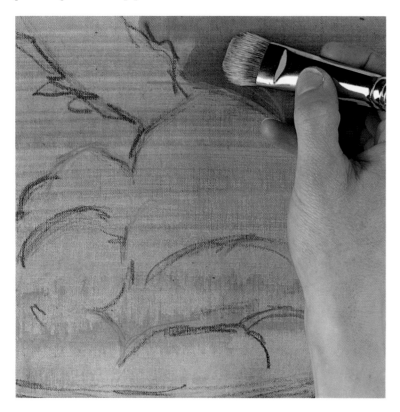

3 *Darker green glazes are added to provide contrast.*

4 *Warm tints of crimson, Yellow Ocher and Chrome Yellow provide emphasis to the rounded forms of the fruit and bowl.*

OLIVE GREEN

YELLOW
OCHER

CHROME
YELLOW

CRIMSON

63

5 *The base colors of the fruit are freely overlaid with a No. 6 short hog's hair flat brush. Further darker tones are added to the background.*

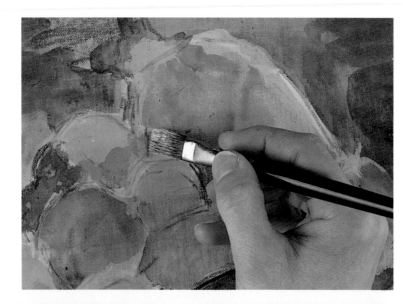

6 *Details are added finally with oil pastels. The idea is to keep everything fresh. Enlivening detail prevents the painting from becoming too settled and "dead."*

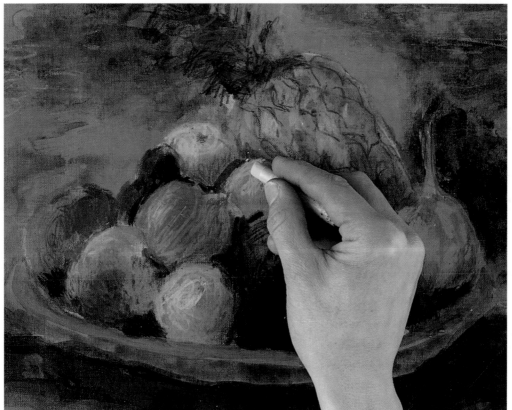

Artist · John Armstrong

1 *The primed canvas has been stained with dilute Raw Sienna using a broad brush. The first marks are drawn with a No. 4 sable brush and Raw Umber.*

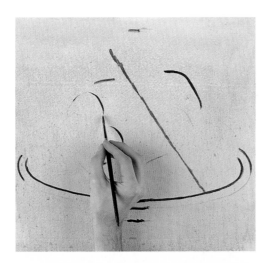

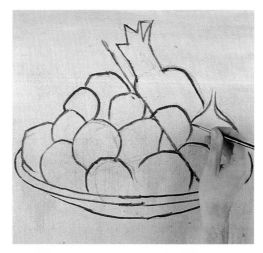

2 *Drawing of the outline continues. This provides the underlying tension or the entire composition.*

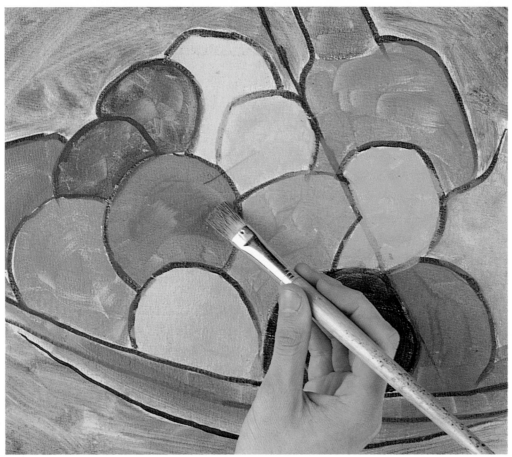

3 *The background is scumbled in with a wash of Terre Verte using a No. 8 hog's hair brush. Base tints of yellow, red, green, brown, and orange are added to the fruit and bowl.*

RAW SIENNA RAW UMBER TERRE VERTE CADMIUM YELLOW PERMANENT YELLOW

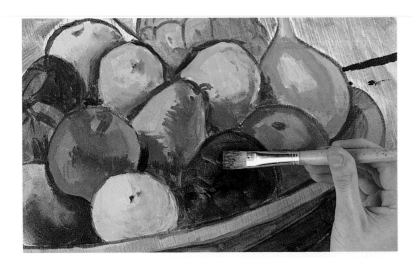

5 *The fruit is repainted in stronger colors and allowed to dry. Detail is added to the pineapple.*

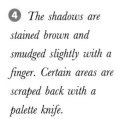

4 *The shadows are stained brown and smudged slightly with a finger. Certain areas are scraped back with a palette knife.*

6 *Colored glazes are laid over the fruit. The background is painted with varying greens including Terre Verte. The table is more clearly defined and the tones modified generally.*

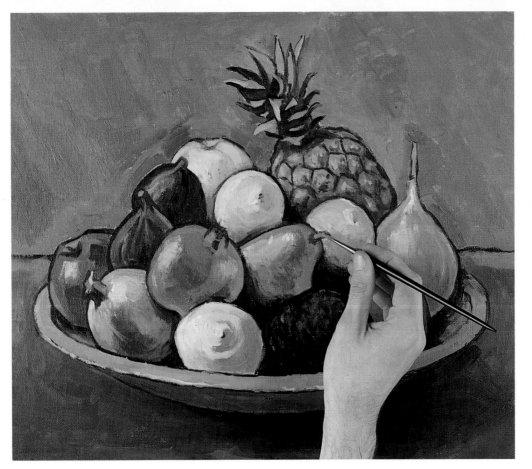

Still Life • *Critique*

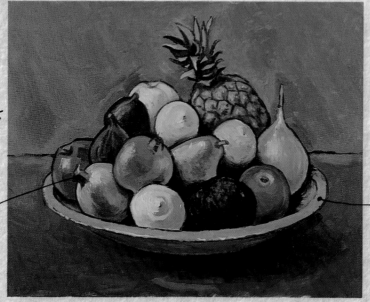

Good contrast
between
primary and
tertiary
colors

JOHN There is a homogeneity of form in this painting – notice, for instance, how the interlocking shapes work, whilst allowing each fruit to retain its own identity. Considerable care has been given to the modeling of the fruit by the balance of color and tone. The shape of the earthenware bowl is defined by the darker undertone of the table, which also contrasts with the rich colors of the fruit.

Bowl well
rendered

Fruit is
painted
convincingly

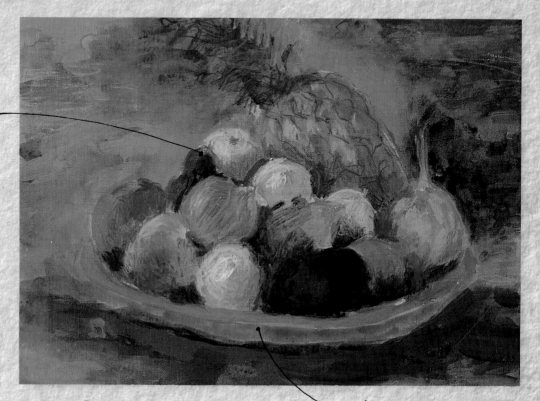

SOPHIE This is a painterly rendition, which does not rely on an underlying linear framework. The forms of the fruits are less distinctly defined. The artist is more concerned with conveying the sense of tactile values, rather than the contours and tonal values. The contours are defined by surrounding glazes of viridian and burnt umber. My only criticism is that I would have liked the artist to have given more consideration to the dimensions of the canvas board in the initial composition.

Good handling
of glazes

Works well in terms of color relationships

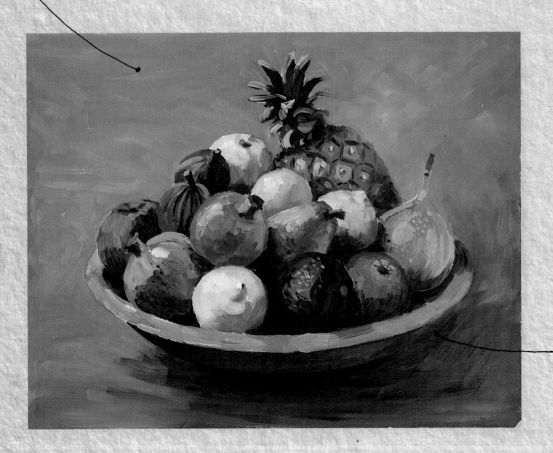

could be more separation between table and background

ROBERT The artist has concentrated on the color and texture of individual fruits using a stippling technique but has failed to consider the overall balance of color and tone. The flatness of the blue-gray background disrupts the sense of three-dimensional space. Darker, thinner glazes of paint would have provided more contrast.

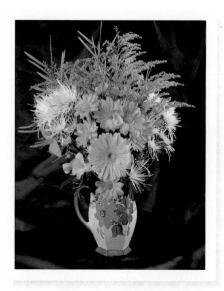

Glazes and Impasto

VASE OF FLOWERS

How can you interpret the delicacy of flowers in terms of oil painting? There are essentially two approaches to the subject. You can use a combination of thin glazes and fine brushwork, or simply try to say something about tonal and color values using the paint with a broad brush and a rich impasto. If, however, you are concerned with fine detail, then it might be as well to work in another medium, such as watercolor or tempera.

Although there is a long tradition of flower painting, it is not often that one sees really good contemporary examples of the genre. All too often, flower painting is seen as a kind of therapeutic hobby rather than as a subject to be invested with serious visual analysis. As with all still-life subjects, you have the freedom to select and group objects to suit your purposes, and to control the lighting in which they are seen.

It is important to try to retain the vigor and vibrancy of the subject, from the first marks made on canvas to the finished painting. If the painting becomes too labored at any stage, it should be scraped back and the forms restated. The artist must sometimes perform rather like a tightrope walker and a dancer at the same time, to harness exuberant shapes and color within a disciplined structure. The speed and energy of the brushstroke can contribute to the liveliness of the work.

Artist · Robert Williams

LAMP BLACK PURPLE LAKE RAW UMBER OLIVE GREEN CADMIUM YELLOW YELLOW OCHER

1 *A rough underpainting is made on primed board with a No. 3 hog's hair brush and Lamp Black. A mid-gray defines the undertone of the vase.*

2 *The background is blocked in with a dark red-brown mixed from Purple Lake and Raw Umber.*

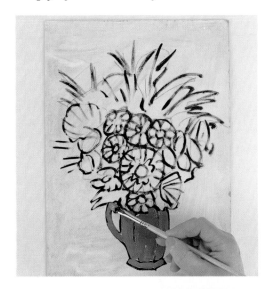

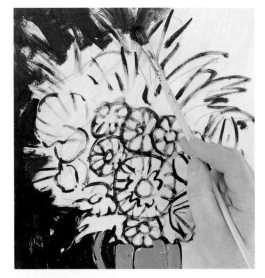

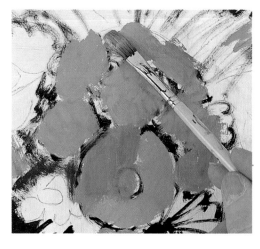

3 *Various tones of red and Yellow Ocher are used as an undertone on the flowerheads.*

4 *An Olive Green is applied broadly to delineate leaf shapes. Further colors are added to the flowers.*

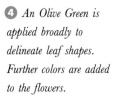

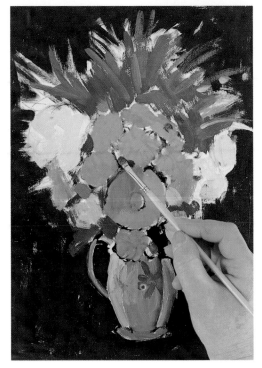

5 *Individual petals and fronds are now finely detailed using the edge of a No. 3 hog's hair brush.*

Artist • Sophie Mason

70

❶ *The main outline of the composition is drawn in oil pastel onto primed board. The drawing is tentatively stated to allow for the painting to be developed in terms of color and tone.*

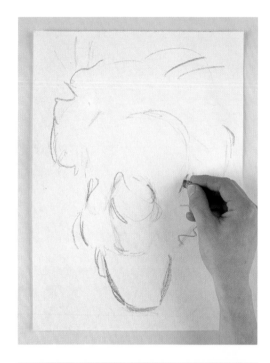

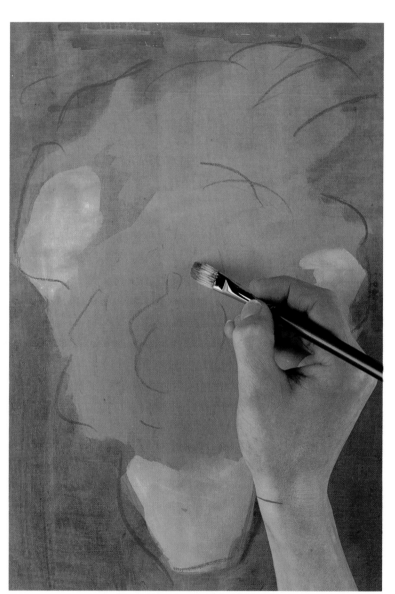

❷ *A rich crimson glaze is brushed over the whole area using a No. 2 short hog's hair brush.*

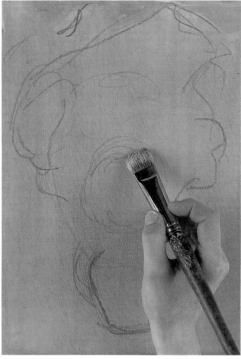

❸ *A glaze mixed from Cadmium Orange, Chrome Yellow and Vermilion is laid on a base color for the flowers. A second glaze of white mixed with Cadmium Yellow is overlaid on the pot and background.*

CRIMSON

CADMIUM ORANGE

CHROME YELLOW

VERMILION

VIOLET

BLACK

4 *The background is made considerably darker with a color mixed from violet, crimson, and black to produce greater contrast. More specific areas of color are painted fairly thickly using a No. 8 short hog's hair brush.*

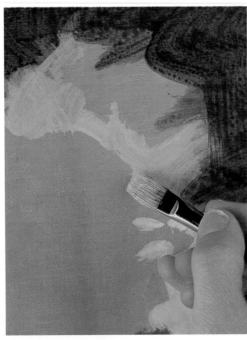

5 *Work continues on the flowerheads using contrasting colors and glazes.*

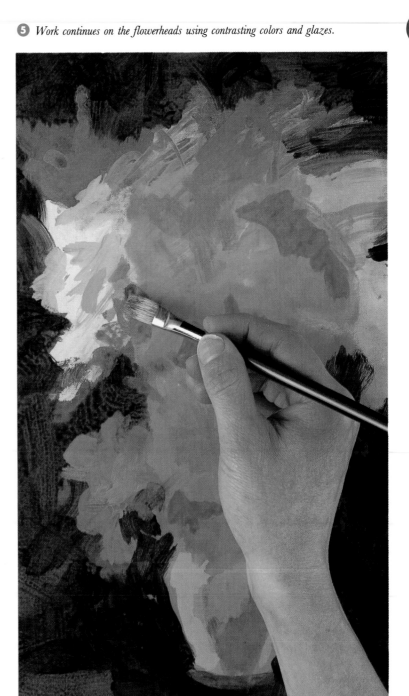

6 *Final details are added to flowers and ferns using a fine sable brush. Oil pastels are also used to produce a variety of tone and contrasting texture.*

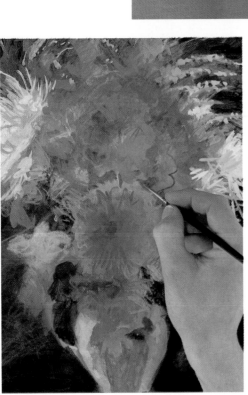

Artist • John Armstrong

1 *The primed board is first stained with Indian Red and, when dry, sandpapered slightly. The general rhythm of the composition is noted with a few strokes of Raw Umber using a No. 4 one-stroke brush.*

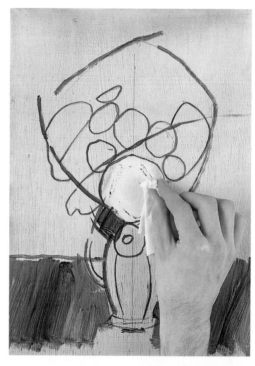

2 *The base color is blocked in using a No. 4 one stroke brush. Some color is wiped off with a tissue.*

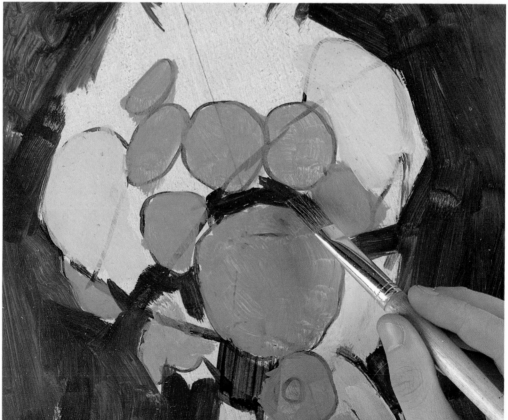

3 *The background is painted in a dark magenta using a No. 7 hog's hair brush. Basic tones are added to the flowerhead and vase. Everything is scraped down slightly.*

INDIAN RED

MAGENTA

RAW UMBER

CHROME YELLOW

OLIVE GREEN

4 *The basic geometry of the interlocking shapes is considered. Details are added to petals, grasses, and ferns, and also to the vase.*

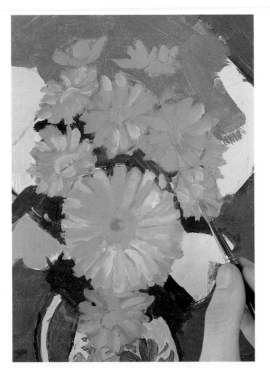

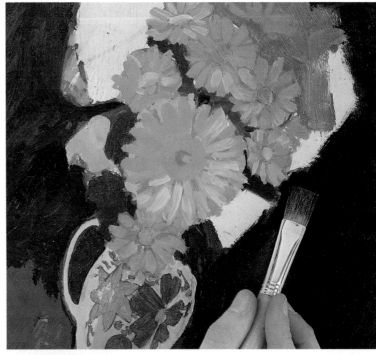

5 *A darker glaze is overlaid on the background with a No. 8 hog's hair brush. Details are picked out using a fine sable brush.*

6 *The white flowers are painted deftly with Titanium White and a No. 6 sable brush. Finally, the tone and color of the table is adjusted in relation to the feel of the painting.*

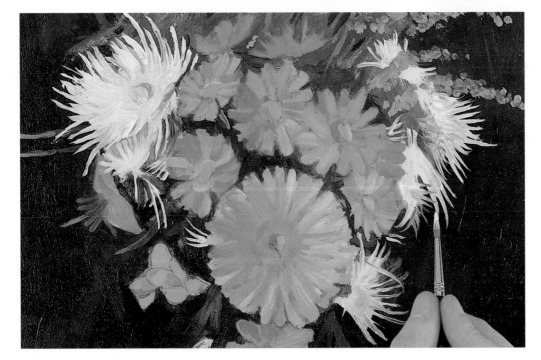

Glazes and Impasto • *Critique*

Background color could be less opaque

ROBERT The symmetry and balance which are critical to a flower study have been given due consideration here. The artist has suggested the delicacy of fronds and petal shapes without being too pedantic. The deftness and liveliness of the brushstrokes suggest movement – flower studies can become too stilted, if one attempts to register every detail. More attention could have been given to the background.

Background tone could be more translucent

JOHN The artist has successfully used both hog's hair and fine sable brushes to produce a variety of brushmarks to render the variegated character of flowers and ferns. The background color could have been more translucent perhaps, so that the contours of the flowerheads are less sharply defined.

SOPHIE One is immediately attracted to the verve and sheer exuberance of this study – it demonstrates how a "still-life" painting can be full of movement. Compositionally, it successfully fills the dimensions of the canvas in such a way that one feels that every element counts. Detail has been sacrificed for exploring the richness of color saturation. Some might feel that too much detail has been left out, especially in the central area of the painting.

Interesting balance between the opaque color and selected linear detail.

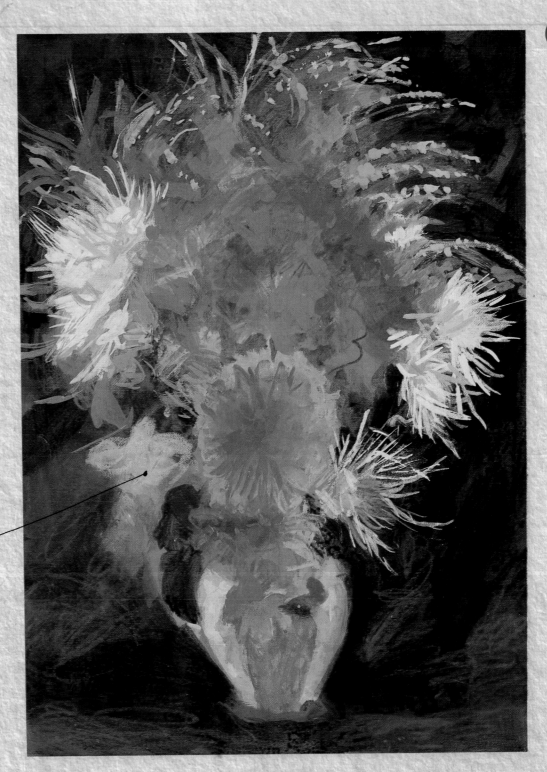

Interior

THROUGH THE WINDOW

The artistic convention of painting a view through a window is almost as old as the history of art itself. It was a favourite device for painters during the Renaissance, and, more recently, for painters such as Bonnard and Matisse. Vermeer and de Hooch also used the open window to create a sense of depth.

Essentially, this kind of painting works on two levels: an interior and exterior separated by a window or door that acts as a framing device linking inside to outside. It is interesting sometimes to see just how much information can be contained within a tiny division of a windowpane.

The complexity of a view seen through a window should be offset by an interior that is fairly sparse; or, conversely, a room that is full of interest should be contrasted with simple forms seen through the window. Of course, adjustments can be made tonally; subdued interior lighting will anyway reduce everything to a simple dark pattern. The position of the artist is fairly critical; the window might take up four-fifths of the picture area, for instance, or be reduced to a diminutive opening on a distant wall.

It is helpful to do a thumbnail sketch to try out the composition before starting the final painting.

Artist • Robert Williams

PRUSSIAN BLUE

COOL GRAY

NEUTRAL GREEN

COBALT BLUE

CRIMSON

1 *An underpainting is made on primed hardboard using a No. 4 hog's hair brush and blue-black.*

2 *A mid-gray tone serves to establish the basic tonal contrasts. The painting continues to be developed in monochrome.*

3 *A pale neutral green and a darker green define the garden and chair seen through the window.*

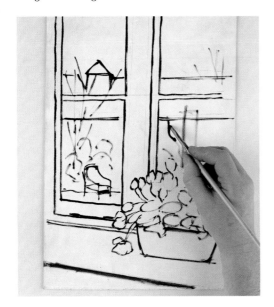

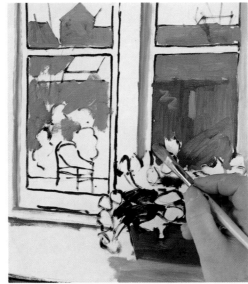

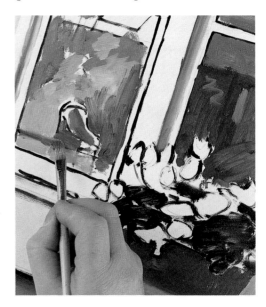

4 *A pale glaze of Cobalt Blue is added to the sky, and the flowers in the foreground are suggested by basic blocks of color.*

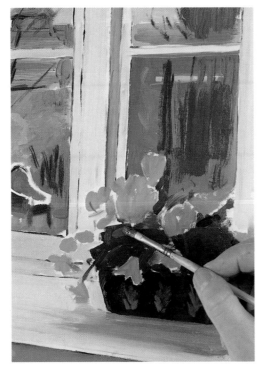

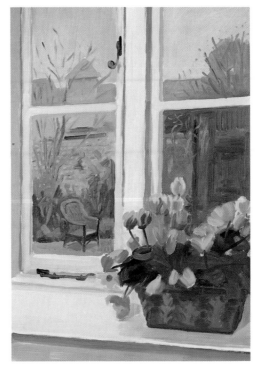

5 *All colors and tones are adjusted in relation to each other. The sky is made closer in tone to the distant buildings. Details are added to the garden, and the flowers are brought into sharper focus in terms of contrast and detail.*

Artist • Sophie Mason

1 *The main structure of the window and the position of the plant are drawn on primed board using crimson and brown oil pastels.*

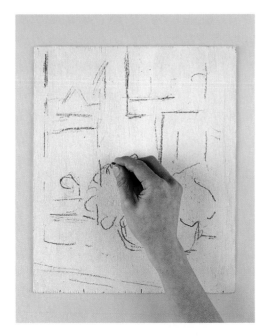

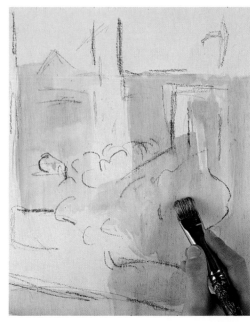

2 *A thin glaze of crimson is overlaid on areas seen through the window and on the plant using a No. 10 short hog's hair brush. This establishes the basic abstract pattern of the painting.*

3 *A glaze of ultra-marine is laid over the sky area, and as a pale shadow on parts of the window.*

4 *Further glazes of pale blue-purple are added to the sky and distant buildings seen through the window. A pale blue, mixed from Cobalt Blue, Titanium White, and a touch of crimson, is painted onto the window frame. At this stage, tones are fairly even.*

BURNT UMBER CRIMSON ULTRAMARINE COBALT BLUE VIRIDIAN TURQUOISE

5 *A glaze of Burnt Umber provides contrast and isolates the plant.*

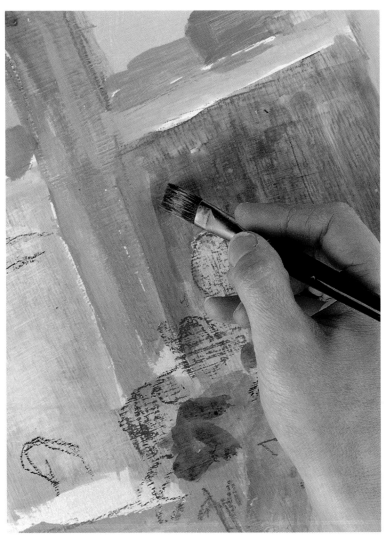

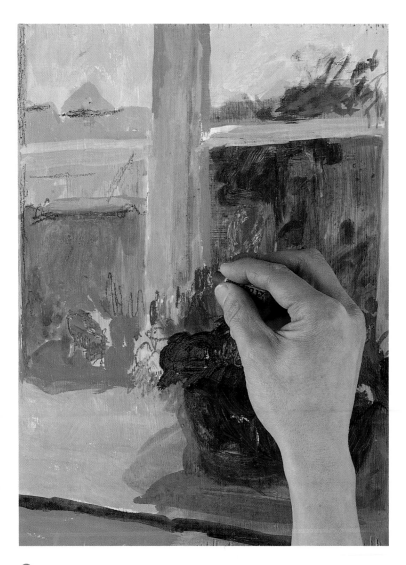

6 *The plant is loosely restated using further glazes, and oil pastels. A further glaze of turquoise is laid over the garden area. The artist has decided that, in order to retain the fluidity of color and the vividness of the light, the painting should be considered finished at this point.*

Artist · John Armstrong

80

1 *The canvas is first stained with dilute Cobalt Blue and allowed to dry. The basic outlines are drawn with a No. 4 sable brush and Indigo.*

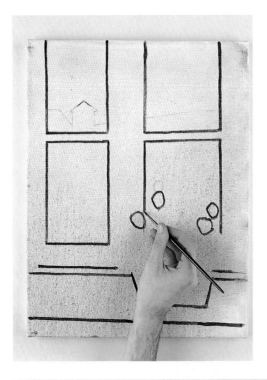

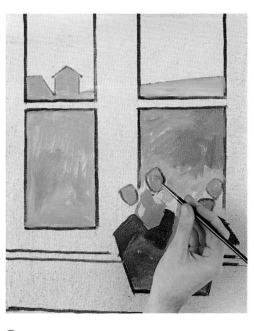

2 *Background tones are defined in flat blocks of gray and green, and the flowers given an undertone of pink.*

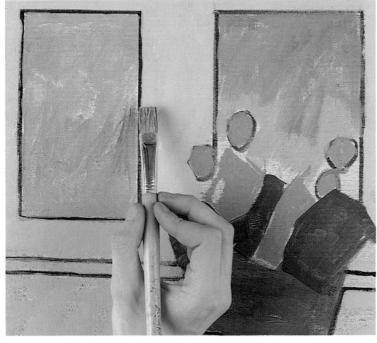

3 *The flat tones of the window frame and sky are blocked in with a No. 8 hog's hair brush.*

COBALT BLUE INDIGO LIGHT PURPLE MID-GRAY CARMINE PINK

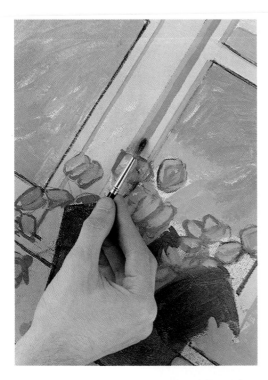

4 *The detail of the window frame is rendered tonally, and the petals of the flowers are more carefully defined.*

5 *Details seen through the window frame, such as the lawn chair, are painted with a No. 4 sable brush. Tones are adjusted generally and more detail added to flowers and leaves.*

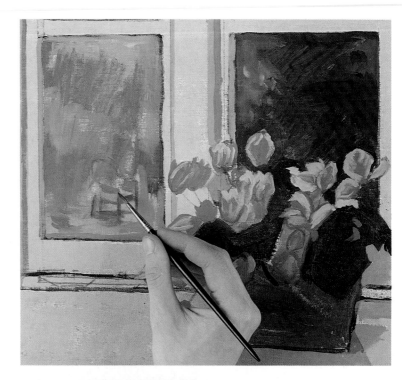

6 *Using a No. 4 sable brush, the forms are more finely delineated. In addition, the sense of distance is made more convincing by establishing separate planes of color.*

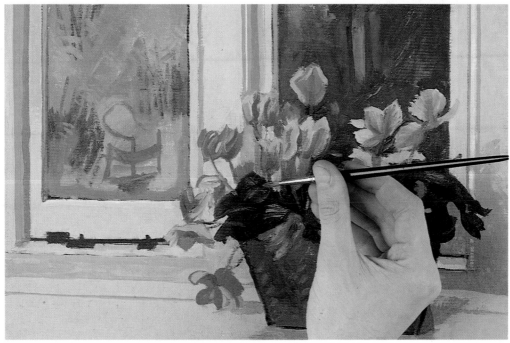

Interior · *Critique*

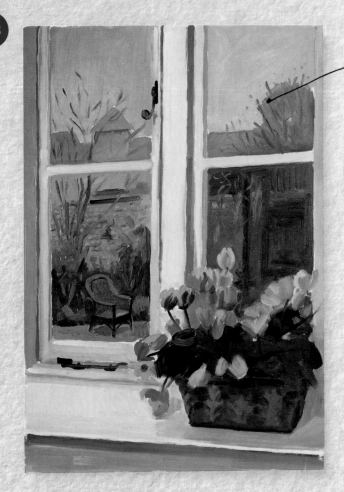

competently handled but rather uninspired

SOPHIE By using thin glazes of scumbled color combined with oil sticks, the artist has produced an atmospheric interpretation of the subject. Again, there are problems in my view with the tone – light and contrast are too level. The delineation of forms is perhaps too understated. The artist could have taken this painting a stage further.

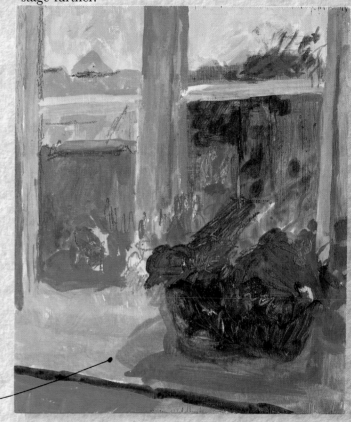

ROBERT Greater contrast of color and tone might have helped this painting. The sense of being inside looking out is lost to some extent by the levelling-out of tone to a mid-gray. The garden could have been made more atmospheric by using thinner glazes so that the forms are less distinct.

Effective use of glazes and scumbled color

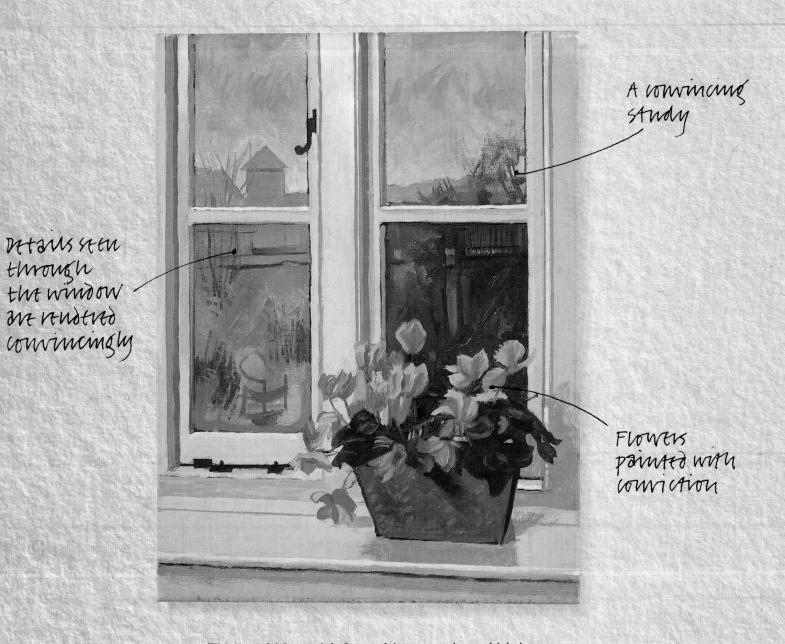

A convincing sandy

Details seen through the window are rendered convincingly

Flowers painted with conviction

JOHN This is a fairly straightforward interpretation, which is deceptively simple. The artist has used the structure of the window as a kind of frame within a frame – so that the eye is led from the flowers diagonally towards the church tower on the left-hand side of the composition.

Sky Study

CLOUDS

In many landscape paintings the sky is often treated as a feature less flat block of color and yet, more than any other element, it can greatly influence the whole mood or drama of a painting. The sky has a structure which is elusive and constantly changing – ponderous clusters of cumulus clouds might break, accumulate, and disperse altogether within a short space of time.

The English painter John Constable (1776–1837) once said, "the landscape painter who does not make his skies a very material part of his composition neglects to avail himself of one of his greatest aids." Indeed, he felt that the sky was the keynote in his painting that often determined the mood or sentiment of his final composition.

It is precisely because clouds are unfamiliar shapes which are constantly changing that we need to observe them with a greater degree of concentration. Clouds have their own vaporous forms which can be seen to recede in perspective; it is not difficult to observe how their size seemingly reduces in scale towards the distance. Most painters find it useful to make rapid notations using a pencil and sketchbook. The sketches can be kept for reference. In drawing clouds, you need to take account of the duality of translucence and semi-opacity, which in turn has to be translated in terms of glazes and impasto. Some painters prefer to work on a colored ground so that it is easier to deal with the properties of color, tone, and structure of cloud compositions.

Artist · Robert Williams

COBALT BLUE

ULTRAMARINE

ALIZARIN CRIMSON

PRUSSIAN BLUE

LAMP BLACK

GRAY

1 *The complexity of the cloud formation, seen in perspective, is first resolved in terms of a pencil drawing on primed hardboard.*

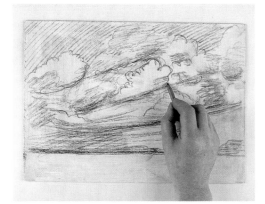

85

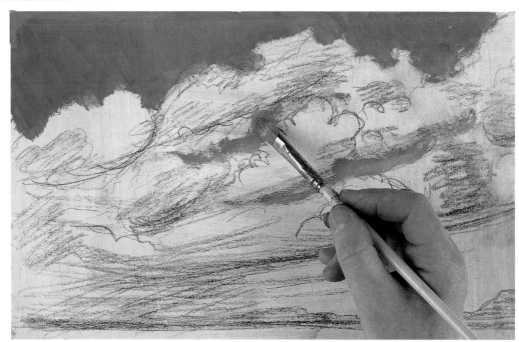

2 *The clouds are defined by a pale tone of blue mixed from Cobalt Blue, Titanium White and a hint of Ultramarine.*

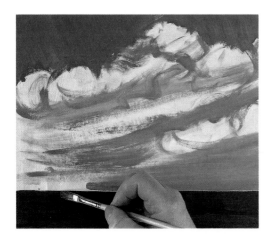

3 *A strong contrasting tone for the ocean is brushed in with a No. 4 hog's hair brush and a mixture of Prussian Blue and Lamp Black.*

4 *The undersides of the clouds are feathered and scumbled with a pale purple mixed from Alizarin Crimson, Ultramarine and Titanium White.*

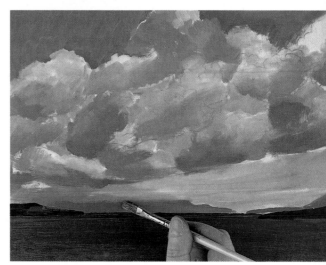

5 *The painting is now resolved in terms of aerial perspective – with the headland in the distance barely discernible as a pale warm gray. The clouds are not fully resolved in terms of contrast, color, and texture. The tone of the ocean is modified in relation to other colors.*

Artist · Sophie Mason

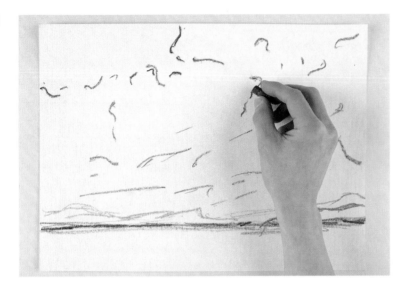

2 *A glaze mixed from Ultramarine and turquoise is laid over the whole area with a No. 10 short hog's hair brush. It is important to get some color onto the canvas quickly. As soon as the first colors are laid, a whole new set of propositions occur.*

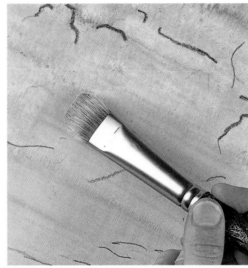

1 *The outline shapes of clouds, headland, and ocean are drawn in oil pastel onto a primed board.*

3 *Passages of Ultramarine are applied thinly to the sky and ocean using a No. 6 hog's hair brush.*

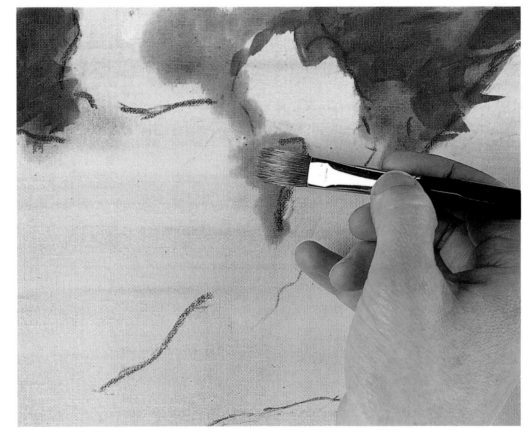

ULTRAMARINE

TURQUOISE

WARM GRAY

PINK

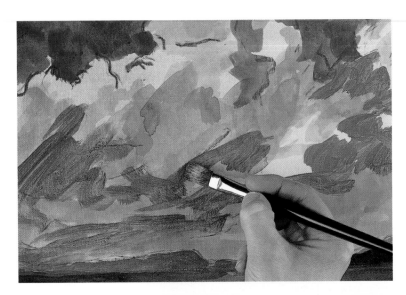

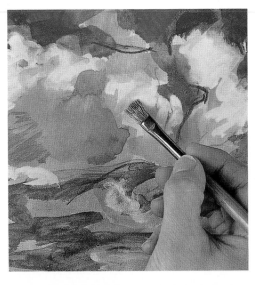

5 *A pink-gray tone is painted selectively on the clouds and lighter passages are restated.*

4 *Further thin glazes of contrasting blues are added to the sky. The headland and the underside of the clouds are painted in a neutral warm gray.*

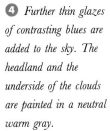

6 *Finally, oil pastels are used to create the fluffy texture of the clouds, and to express their movement.*

Artist · John Armstrong

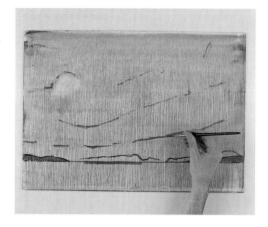

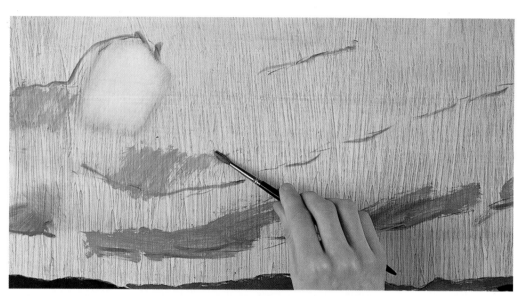

❶ *The primed board has been stained with dilute blue with just a tinge of red and allowed to dry. The main outlines are drawn in Cobalt Blue, using a No. 4 sable brush.*

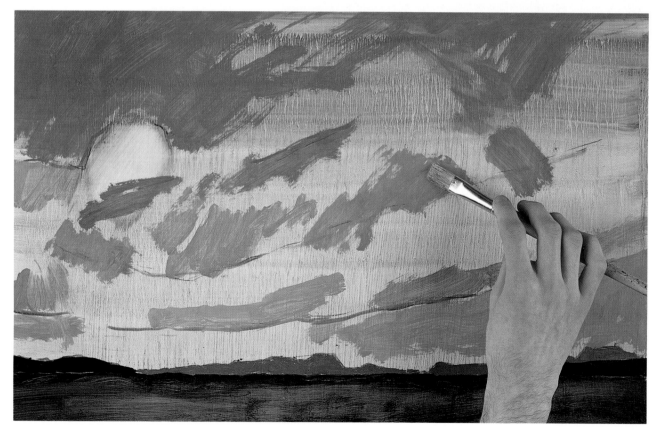

❷ *The dark tone of the ocean is mixed from Cobalt Blue, Payne's Gray, and Burnt Sienna and blocked in with a No. 8 hog's hair brush. Further tones of midgray are added to the headland and the underside of the clouds using a No. 4 sable brush.*

❸ *Dark and light tones of Cobalt Blue are added to the sky. Part of the color is scraped away before beginning the next stage.*

COBALT BLUE

PAYNE'S GRAY

BURNT SIENNA

LIGHT GRAY

WARM GRAY

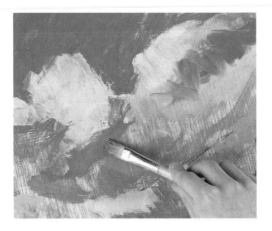

4 *The underside of the clouds is scumbled with light and dark gray. The color is rubbed with a finger afterward.*

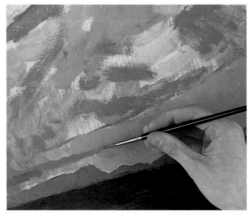

5 *Clouds are repainted using a No. 4 sable brush and a soft rag. The tone is made paler on the horizon.*

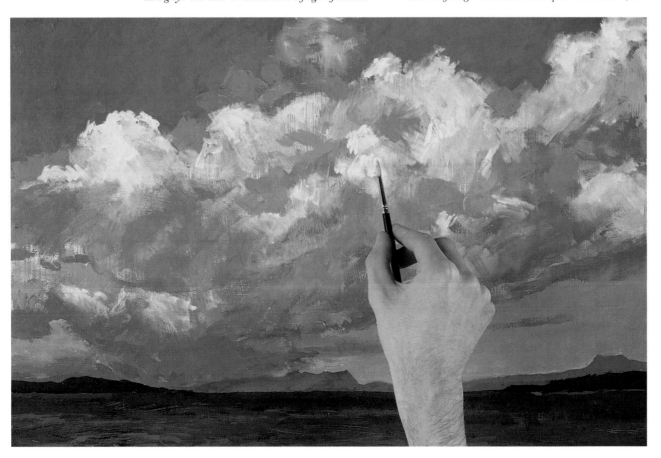

6 *A warm gray has been glazed over the ocean and the white of the clouds painted thickly with a No. 4 sable brush. Even in the final stage, the brush-work is kept free to retain the spontaneity of the first stages.*

Sky Study · *Critique*

Painting works better in early stages

ROBERT The strata of clouds in the top left-hand part of the painting have been handled convincingly, but the underside of the clouds as they recede towards the horizon are less plausible. I much preferred this painting when seen at stage 5 – the brushwork at that point was freer and the forms softer.

works well in terms of light and aerial perspective

JOHN This painting demonstrates an effective use of aerial perspective to suggest depth and recession. In terms of handling, it is, I feel, the most successful study of the three. Cloud studies can be notoriously difficult to register in terms of brushmarks. Here the artist has convincingly represented the nebulous strata of advancing clouds using a No. 8 chisel-edged brush to scumble the basic shape, later introducing finer strokes with a No. 4 sable.

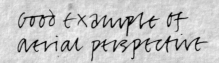

Good example of aerial perspective

Paint and pastels combined

Symbolic rather than realistic

SOPHIE The conventions of aerial perspective and tonal recession are less apparent in this study. The artist, I would suggest, has been concerned more with symbolism than with the illusions of three dimensions. Essentially, she has tried to capture something of the process of trans-mutation — allowing for the constantly shifting patterns of light and shade created by moving clouds.

Nature Study

TREES

Sir George Beaumont once asked Constable, "Do you not find it very difficult to determine where to place your brown tree?" "Not in the least," replied Constable, "for I never put such a thing into a picture." We sometimes crudely and unthinkingly tend to categorize our visual experiences in terms of convenient clichés. Tree forms are as unique and individual as human forms, and to draw or paint them requires the same degree of concentration that you would expect to find in a life class.

Constable also said that we see nothing until we truly understand it. All too often our preconceptions of what a tree ought to look like get in the way of real discovery. It is important to remember that each tree is firmly rooted in the ground as a growing organic form. The verticality of its structure is complementary to predominantly horizontal landscape forms. A tree seen in winter, when it has shed its leaves, will look different in high summer, when the abundant foliage will create an entirely different outward shape.

When looking at a drawing or painting of trees you can sometimes see exactly where the artist's interest has tailed-off; lapses in concentration result in clumsy execution in the drawing of branches and leaves. Any tree study, however, must be a summary of things seen – excessive detail often conceals far more than it reveals. Try to capture the main thrust of the trunk and main branches without worrying too much about individual leaves.

Artist • Robert Williams

WARM GRAY COOL GRAY INDIGO LAMP BLACK RAW SIENNA OCHER

1 *Two thin glazes of warm and cool gray make the pale background tone. The low horizon line is established and the basic shape of distant trees suggested by a roughly blocked-in gray mixed from Indigo, Lamp Black, Titanium White, and a touch of Raw Sienna.*

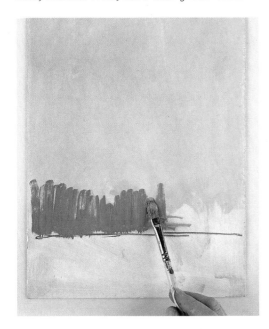

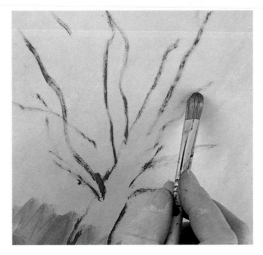

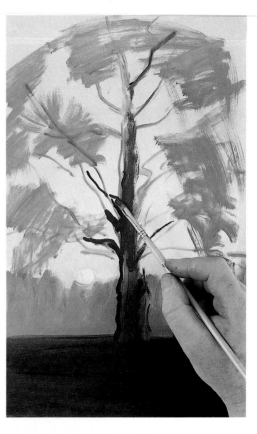

2 *The basic structure of the tree is painted with a No. 4 hog's hair brush in mid-gray. A darker gray is added to the foreground.*

3 *The rough basic shape of the foliage is overlaid in pale ocher and the sun is registered on the horizon.*

5 *Tones are further modified to produce a contre jour effect (against the light). Details are added to the copse of trees in the distance.*

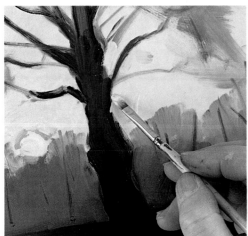

4 *The tone on the horizon is made warmer and further details added to the tree.*

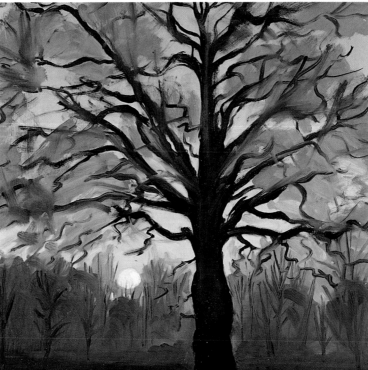

Artist · Sophie Mason

94

❶ *An outline drawing of the tree is made directly onto primed canvas using oil pastel.*

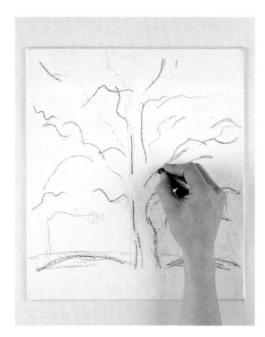

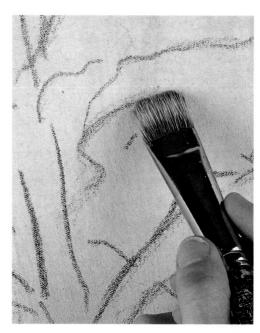

❷ *A thin transparent glaze of crimson is brushed over the surface with a No. 10 short hog's hair brush.*

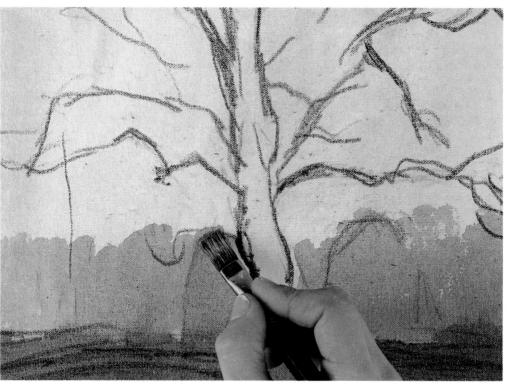

❸ *Glazes of Burnt Umber and violet are painted in the foreground and as a lighter tone in the background.*

CRIMSON BURNT UMBER VERMILION VIOLET GRAY

4 *Burnt Umber is added to the tree and as a pale uneven tone over parts of the sky.*

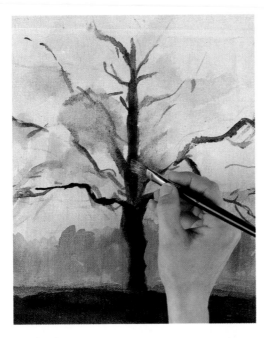

5 *The sun is painted white on the horizon, further glazed passages are added selectively in crimson, Vermilion, and Burnt Umber.*

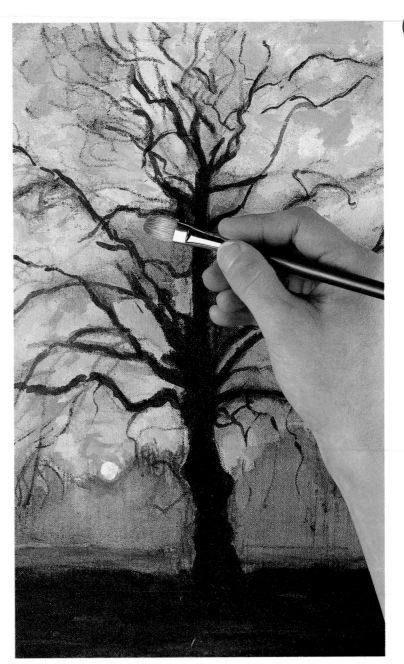

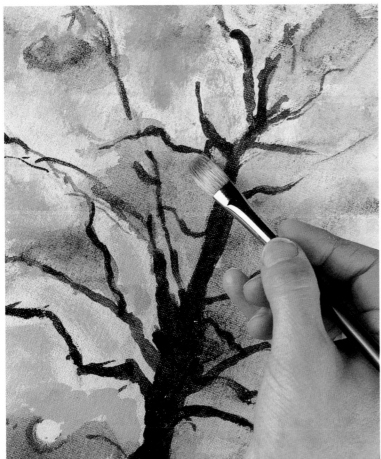

6 *Contours are softened and more detail added to branches of the tree. Details are also added sparingly to the trees in the background.*

Artist · John Armstrong

96

❶ *A colored ground is produced with a stain of Payne's Gray and allowed to dry. The tree is drawn in a deep blue using a No. 4 sable brush.*

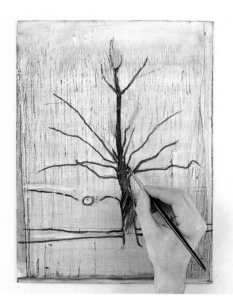

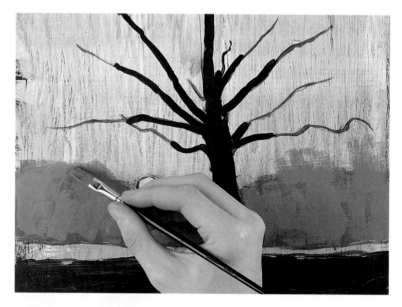

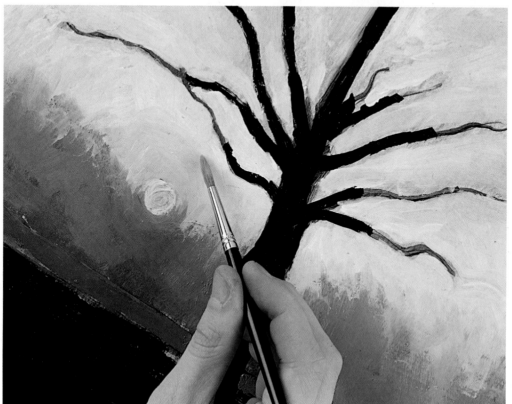

❷ *A mid-gray is blocked into the disant trees using a No. 7 nylon brush. A dark tone is added to the foreground.*

❸ *The tone of the sky is produced by mixing Cobalt Blue, Chrome Orange and Zinc White. A warmer tone of orange-pink is painted on the horizon. The gray of the distant trees is smudged with a rag.*

PAYNE'S GRAY

INDIGO

COBALT BLUE

CADMIUM RED

CADMIUM YELLOW

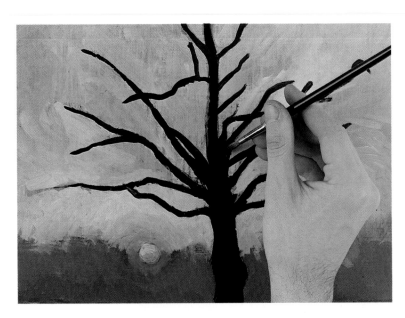

4 *Work continues on the branches of the tree.*

5 *Dry brushwork using a No. 6 hog's hair brush adds depth.*

6 *All the tones are now finally modulated and more dry brush-strokes are added to the extremities of the branches. A lighter tone is painted between branches using a No. 6 nylon.*

Nature Study · *Critique*

98

JOHN The blend of warm and cool hues in this painting produces a strongly atmospheric evocation of a wintry scene. Color and tone have been carefully controlled to produce a pallid, subdued light. This is an unpretentious rendering of the subject, and my only criticism is that the tone in the foreground is too dark.

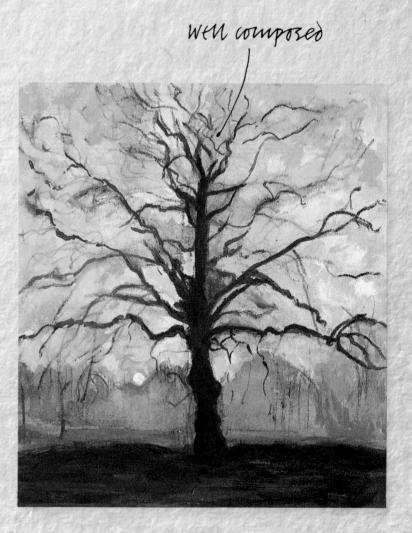

well composed

The foreground tone is slightly dark

SOPHIE The tree-form is well composed within the canvas. The subject is treated in a semi-abstract way. The painting goes beyond being a factual recording of the subject, impinging more on the artist's emotional responses to the theme. The artist has successfully resisted the temptation to "finish" the painting by building up an unnecessary impasto, or by adding further detail.

GOOD USE OF
CLOSELY-RELATED
TONES

ROBERT This almost monochromatic rendering of the subject again conveys something of the atmosphere of a cold wintry day. I do feel, however, that the spread of the branches of the tree is somewhat confined by the dimensions of the canvas. Silhouetted forms, such as the tree, are difficult to handle, and every branch needs to be expressed with conviction to prevent the whole thing from drifting into formlessness.

Perspective

FORMAL GARDEN

The formal aspect of a landscaped garden presents the artist with an interesting subject in terms of composition. Harmony of line, proportion, and balance are inherent in the best of such gardens, many of which have been modeled on the work of Andrea Sansovino and Andrea Palladio in Italy, and on André Le Nôtre's creations for Louis XIV's Palace of Versailles in France. These gardens were laid out in accordance with the rules of classical symmetry. Loggias, statuary, topiary, fountains, and dividing walls provide visual incidents that offset the severity of the geometric plan.

When painting a garden scene, consideration should be given to color and contrast to heighten the formal qualities rather than conceal them. Perspective, of course, plays a vital part in representing the spatial dimension of formal gardens. The choice of viewpoint and selected eye-level can also significantly effect the success or failure of the painting.

Artist · Robert Williams

LAMP BLACK

VIRIDIAN

GERANIUM LAKE

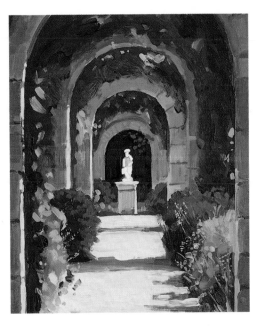
FRENCH ULTRAMARINE

NAPLES YELLOW

YELLOW OCHER

❶ The main structure of the arches seen in perspective is rendered as an underpainting using a No. 6 long flat hog's head bristle and Lamp Black on primed hardboard, firmly establishing the composition.

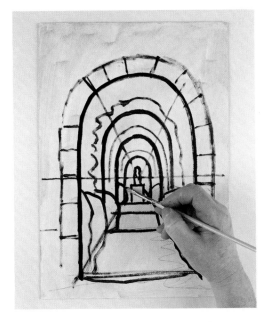

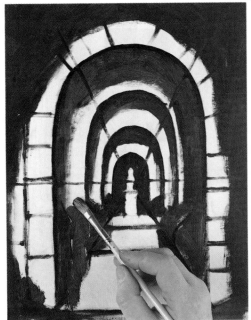

❷ From dark to light, the darkest tones, mixed from Lamp Black and Viridian, are applied as a thin layer with a No. 6 long flat hog's head bristle brush.

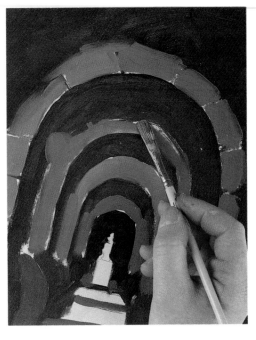

❸ The stonework of the arches is painted with mid-toned mauve mixed from Geranium Lake and French Ultramarine.

❹ The basic shapes of the overhanging vines, shrubs and foliage are roughly established with a pale green mixed from Viridian, Flake White and a touch of Naples Yellow. The path leading to the statue is blocked in with a neutral tint of ocher modified by Titanium White.

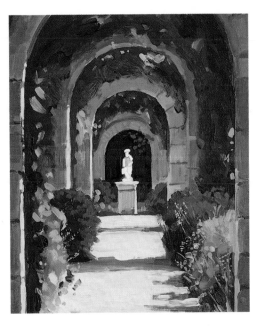

❺ Everything is given much greater definition, including detail on the stonework, flowers, shrubs and the statue. Contrasts of light and shadow are more sharply represented.

Artist • Sophie Mason

1 *The arches are freely drawn in oil pastel onto a primed board.*

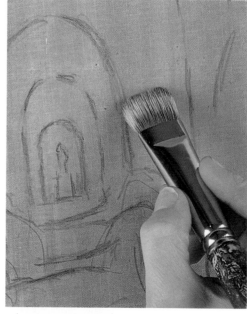

2 *A glaze mixed from gray and French Ultramarine is laid over the whole area using a short flat hog's hair brush.*

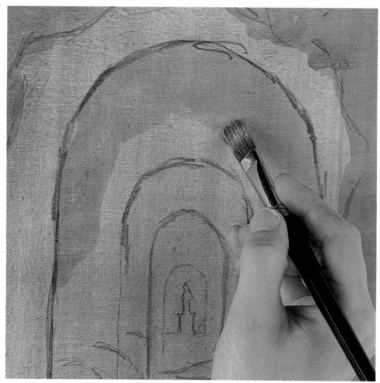

3 *A thin glaze mixed from French Ultramarine and Hooker's Green separates the arches and provides a base color for the foliage.*

WARM GRAY FRENCH HOOKER'S GREEN TURQUOISE GERANIUM LAKE
 ULTRAMARINE

4 *Tones are darkened around the arches and the path picked out in a tint of opaque turquoise.*

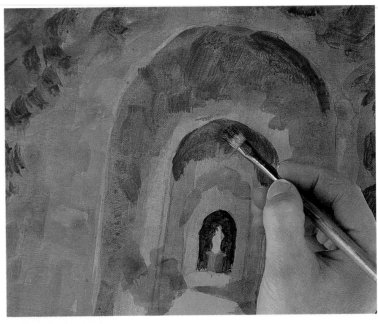

5 *The broad underlying shapes of the foliage are established with No. 6 short hog bristle brush, and the recesses are darkened generally.*

6 *The whole painting is given greater contrast and a sense of depth. More brilliant color is added to the foliage and to garden flowers, using a No. 4 sable brush. Other forms are heightened with tentative strokes of oil pastel crayons.*

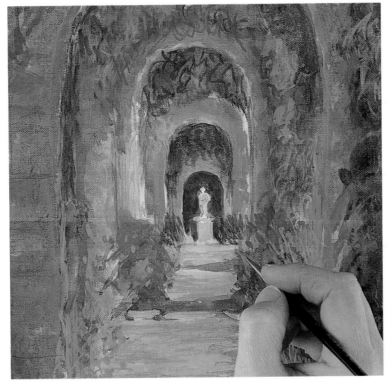

Artist · John Armstrong

104

❶ *The primed board is first stained with a dilute mix of Payne's Gray and Cobalt Blue. The first tentative marks are made in Raw Umber using a No. 4 sable brush.*

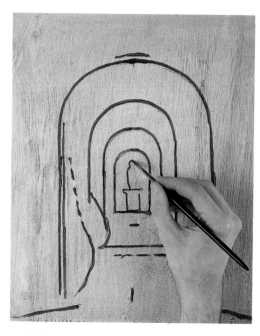

❷ *The sequence of four arches and the distant statue are drawn in perspective with dilute Raw Umber.*

❸ *Titanium White, Raw Umber, and Cobalt Blue are mixed to produce a blue-gray for the stone arches. A base tone for the foliage is mixed from Terre Verte, Cobalt Blue, Raw Umber, and a touch of white.*

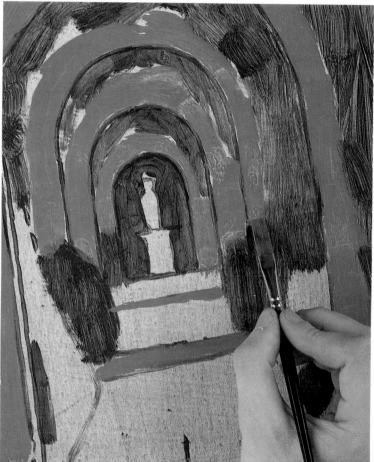

 PAYNE'S GRAY COBALT BLUE RAW UMBER TERRE VERTE WARM GRAY SPECTRUM RED

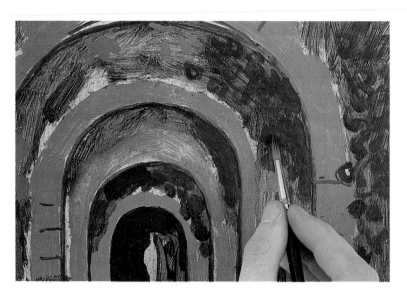

4 *Details are added to the greenery with a No. 4 sable brush. Contrasting tones of gray are painted over the path.*

5 *The statue is painted a gray-white.*

6 *Final details are added to flowers with touches of Spectrum Red and highlights added to foliage with a No. 4 sable brush.*

Perspective · *Critique*

Lack of contrast makes the painting appear rather flat

JOHN The painting is handled competently in terms of perspective and composition – I would like to have seen more contrast between the arches as they recede into the distance. Nevertheless, there is a feeling of light and space, and flowers and foliage are painted with much understanding.

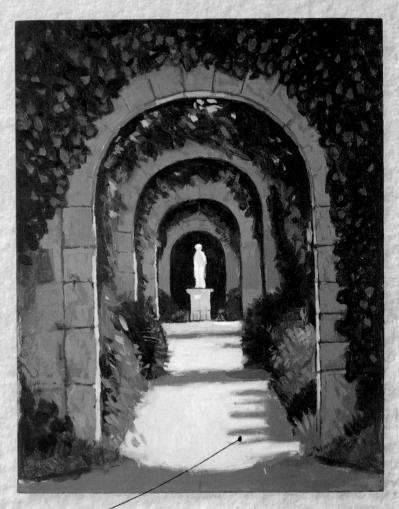

SOPHIE The light in this painting is more subdued – perhaps too much so. The coloration works well with balanced hues of blue and green, but there is no real sense of depth. If the initial drawing and composition are weak, it is difficult to save the painting unless the basic structure is restated more convincingly.

Good feeling for light and space

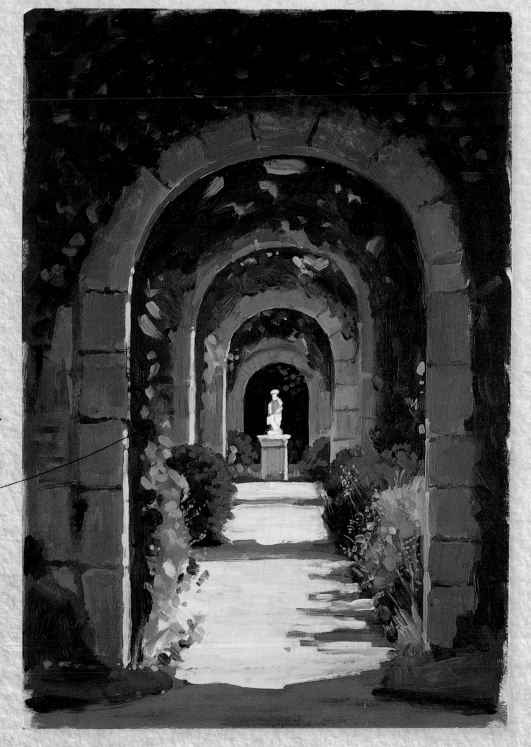

sense of
recession is
convincing
in this
study

ROBERT This, I feel, is the most successful of the three. The contrasts of light and shade, tone and color, have been carefully judged so that the eye is drawn toward the center of the composition without being distracted by extraneous detail.

Landscape

SUNSET IN THE MOUNTAINS

The Cumbrian mountains seen at sunset provide the inspiration for the landscape project. Toward dusk, the failing light negates distance and seemingly reduces everything to a flat, two-dimensional pattern.

Hill farmers in this part of England build drystone walls that follow the contours of hills and valleys. Working with an assortment of stones in different shapes and sizes, they skillfully fit the stones together in such a way that the wall is of even height and width. I mention this because the artist is faced with a task that is analagous to that of the hill farmer. Basic shapes that are

symbols for the sun, sky, mountains, and forest must be fitted together to form an interlocking harmonious composition.

The word symbol comes from the Greek *sumbolon,* which means token. We are able to recognize and accept certain basic shapes as being representative of our wider visual experience. So to depict forms symbolically, we must show their most characteristic silhouette. If the shapes are difficult to identify, we risk failure in communicating exactly what we wanted to say about the subject. In a project of this kind it is important to produce a satisfactory underlying design before starting to paint.

Artist · Robert Williams

PRUSSIAN BLUE

BLACK

LIGHT PURPLE

COOL GRAY

CADMIUM ORANGE

1 *The truncated contours of the mountains are represented as flat shapes of color. A No. 6 hog's hair brush is used to block in rich warm blues and a blue-black.*

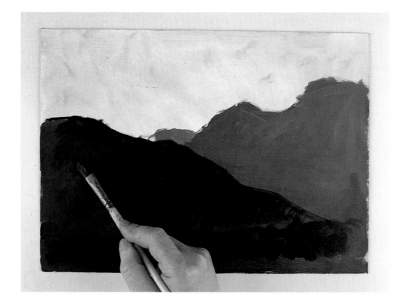

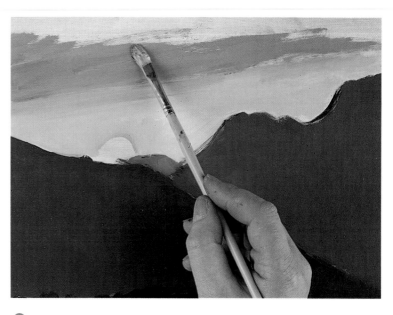

2 *A pinkish-gray and light purple are added to the sky, isolating the sun on the horizon.*

3 *The sun and the light radiating from it are evoked in terms of gradated color. All the color and tone of the landscape and sky is modified through the subtle blending of colors of the same hue.*

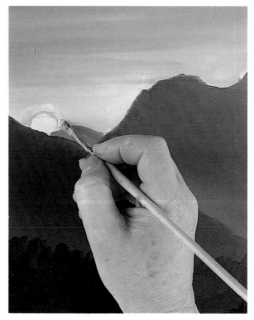

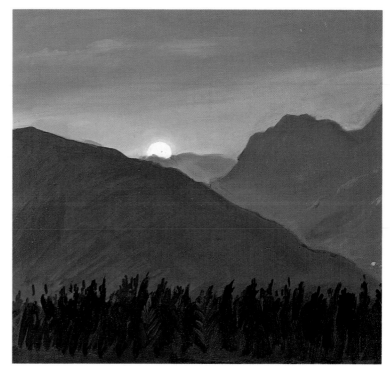

4 *Trees in the foreground are rendered as silhouettes without being too conspicuous.*

109

Artist • Sophie Mason

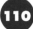

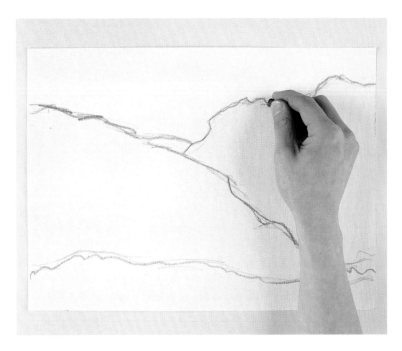

2 *A crimson glaze is stained over the whole area using a No. 10 short hog's hair brush.*

1 *The outline forms of the mountains are loosely sketched in oil pastel onto primed board.*

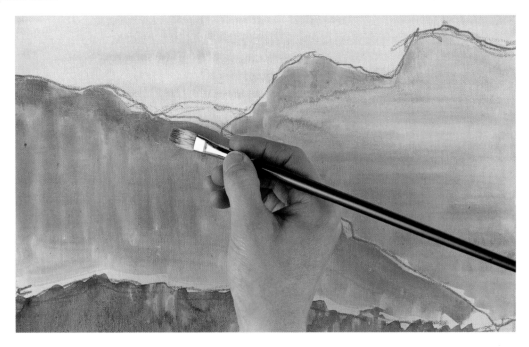

3 *Thin glazes of French Ultramarine, Cobalt Blue, and Alizarin Crimson are overlaid on the mountains and foreground. In order to control the development of the painting, the artist allows the tonal values to accrue gradually.*

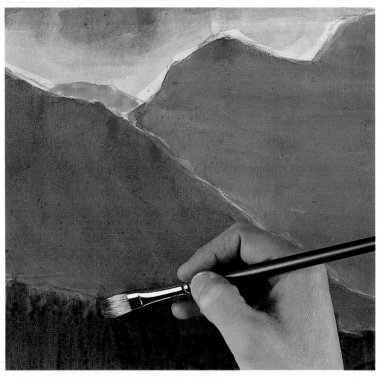

ALIZARIN
CRIMSON

COBALT BLUE

FRENCH
ULTRAMARINE

COOL GRAY

RAW UMBER

5 *A thin, dark glaze is added to the sky to create drama and contrast. The colors of the mountains are intensified.*

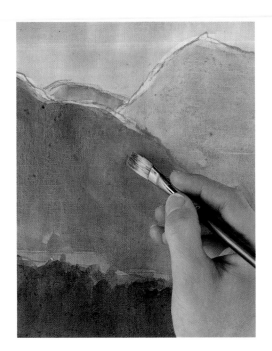

4 *Tones are modulated in relation to each other, with the darkest tone in the foreground.*

6 *Details are added with oil pastels. Further glazes are also added to mountains and to the forest in the foreground.*

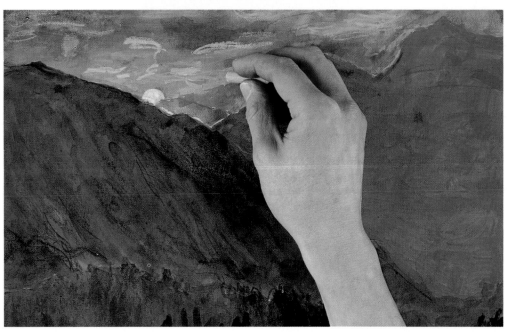

Artist • John Armstrong

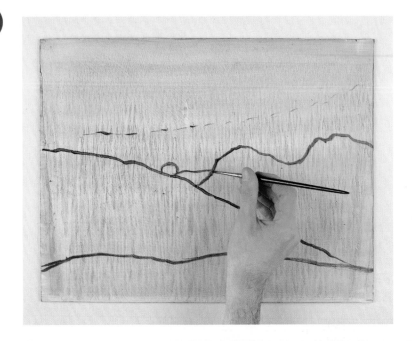

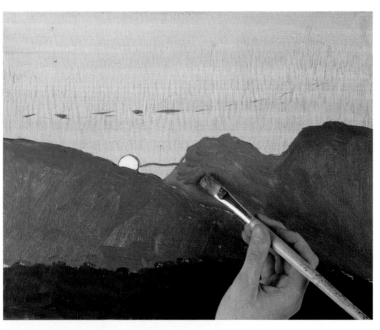

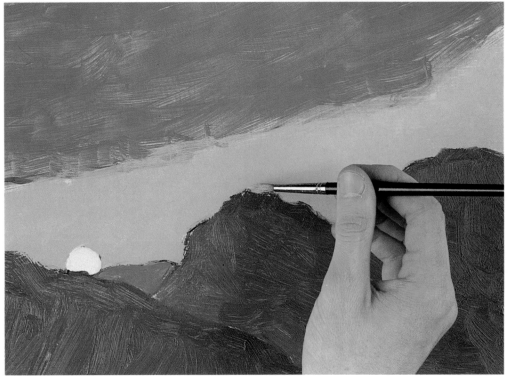

1 The primed board has been stained with dilute scarlet and allowed to dry. The contours of the mountain are briefly stated in blue using a No. 4 sable brush.

2 The mountains are blocked in with a color mixed from Payne's Gray, Violet, and Titanium White. The sun is painted as a white disk on the horizon.

3 A gray-blue is added to the sky and when dry, a second glaze mixed from Vermilion and Chrome Yellow, and white is laid on top.

| SCARLET | PAYNE'S GRAY | VERMILION | VIOLET | CHROME YELLOW | CADMIUM ORANGE | COBALT BLUE |

113

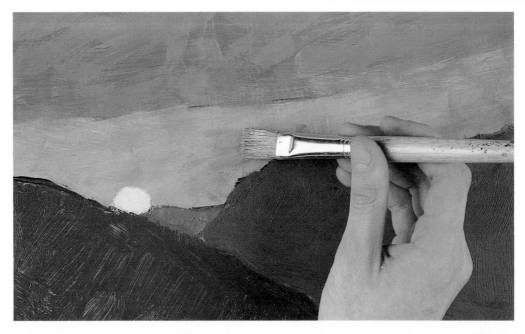

4 *A Scarlet glaze is laid over the painting with a No. 8 hog's hair brush.*

5 *The glaze over the sky is repainted, wiping out the area near the sun. A Cadmium Orange glaze is painted around the sun.*

6 *An impasto of a darker tone is added to the mountains using a palette knife.*

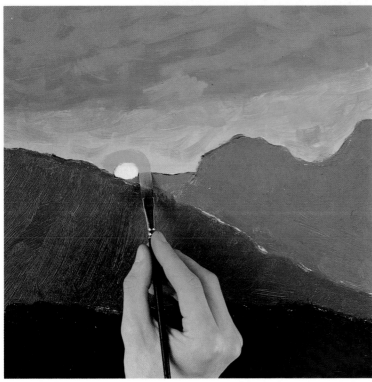

Landscape · *Critique*

subtle blending of color and tone

ROBERT In a landscape such as this, the distances involved are discerned through veils of pellucid atmosphere that moderates color and tone. In this painting the artist has dealt with this aspect more convincingly than the others. It requires the ability to blend color and tone in a very subtle way.

SOPHIE The artist has sought to provide some sense of animation to an otherwise dull scene. By adding texture to mountains and sky she has gone some way to improve the painting. But the problem remains more fundamental in terms of the viewpoint and composition. I also feel that the tones are too evenly balanced, producing an effect rather like a theatrical backdrop. Perhaps a different vantage point would have produced a more dramatic picture.

could have chosen a better viewpoint

Is there enough interest?

Good color harmony

JOHN Here the truncated shapes of the mountains are reduced almost to abstraction. But even in abstract terms I feel that all the elements are too evenly balanced. The setting sun remains the only point of focus – is enough happening in this painting? Would it be improved, for instance, by adding a single vertical element?

Travel

BOATS AT ANCHOR

A flotilla of pleasure craft at anchor in the still waters of a New England inlet provides a suitable vehicle for testing an artist's ability to bring all the diverse elements together into a meaningful composition. Still water produces mirror-images that add another dimension to the painting by accentuation.

The shapes of boats are deceptive and sometimes difficult to draw. Seen from varying angles, the structure is further complicated by the curve around the hull and from prow to stern. In addition, there are cabins, rigging, and masts to take into account.

When drawing or painting this kind of subject, selection is all important; the harbor may be full of boats, but the particular dis-position of these elements in your composition is what counts. You do not have to register everything; if it helps your com-position to leave out one or more boats altogether, then there is no particular virtue in keeping them in simply because they are there. It is worth remembering that the artistic values of a painting are independent of the subject – one does not need to be interested in sailing, or even to like boats, to find them useful in constructing a satisfying and enjoyable picture.

You must learn to translate what you experience when confronted by nature – to convey something of the immediacy of the sub-ject, and of the shifting values of light and shade.

Artist · Robert Williams

CADMIUM GREEN

LAMP BLACK

YELLOW OCHER

FRENCH ULTRAMARINE

INDIAN RED

COOL GRAY

① *The composition and basic tonal pattern is resolved in an underdrawing made with a soft graphite pencil on primed board.*

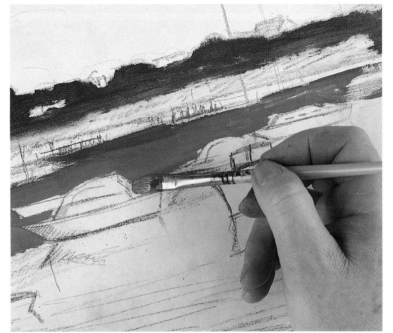

② *The tree line on the horizon is blocked in with a green-black mixed from Lamp Black and Yellow Ocher. A warm blue based on French Ultramarine isolates the boat shapes.*

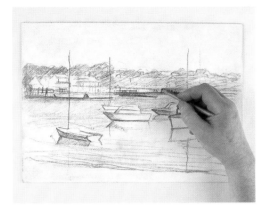

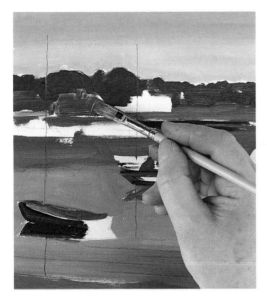

③ *Further blues are applied as thin glazes and Indian Red added to the shoreline. Work continues on the shoreline, foreground, and shadows on the boats.*

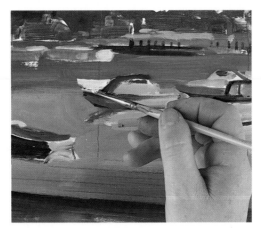

④ *Mid-tones of warm and cool grays, white and Yellow Ocher provide tonal contrast.*

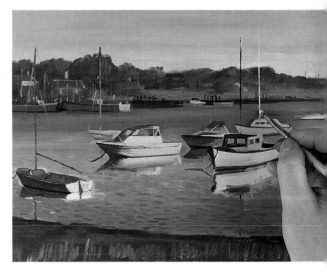

⑤ *Details on the boats, such as masts and cabins, are highlighted using the edge of a flat hog's hair brush. Reflections and the effect of dappled water are expressed by stippling, and tones are finally modified in relation to each other.*

Artist · Sophie Mason

118

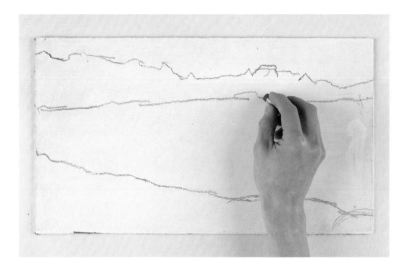

❶ *The mainland and harbor are defined with oil pastels on primed board.*

❷ *Glazes of lilac and gray are overlaid with a No. 10 short hog's*

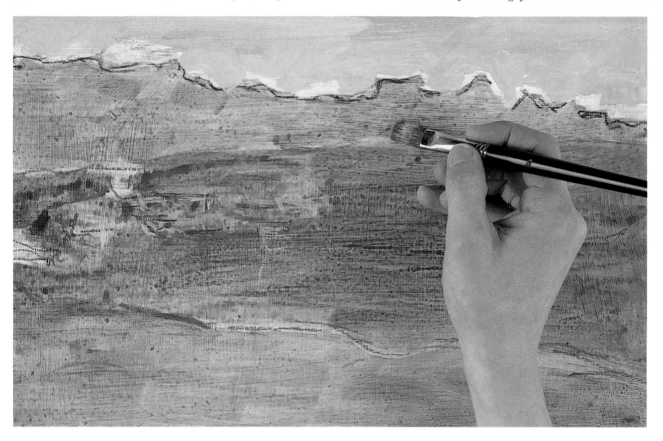

❸ *The mainland is glazed with a color mixed from Yellow Ocher and Olive Green.*

YELLOW OCHER OLIVE GREEN LILAC WARM GRAY ULTRAMARINE VIOLET BLACK

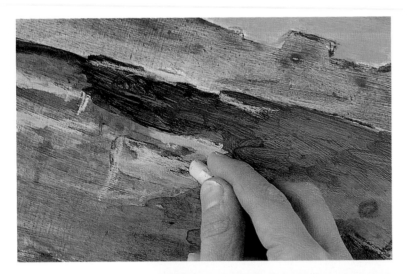

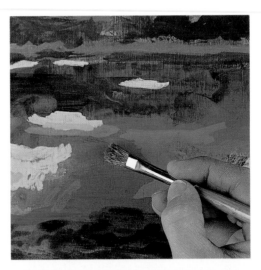

119

5 The tone of the sky is darkened considerably using a color mixed from black, violet, and Ultramarine. Olive Green and Yellow Ocher are added to the mainland. The boat shapes are established using a mixture of Ocher and white, and darker tones are overlaid on the water.

4 The shapes of the boats are drawn over the dried blue glaze using yellow oil pastel.

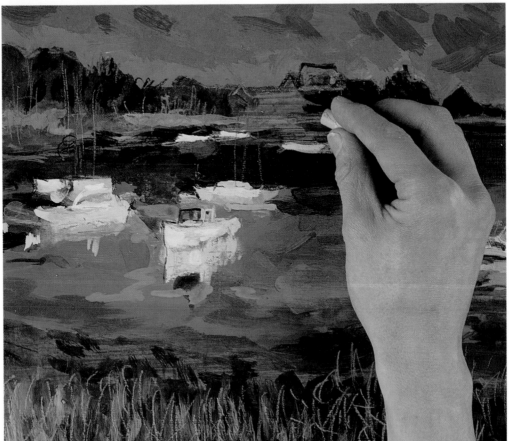

6 Final details are added using oil pastels on grasses in the foreground and for added texture to the sky.

Artist • John Armstrong

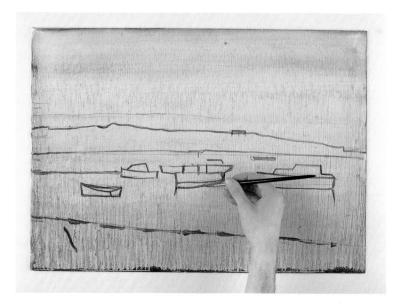

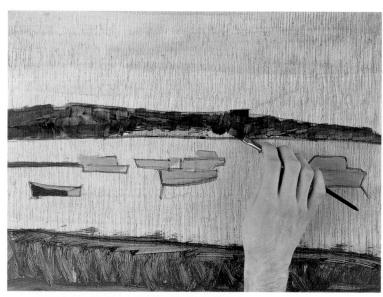

❶ *A thin wash of Payne's Gray is applied to the primed board and allowed to dry. The main outlines are drawn in a color mixed from Terre Verte and Burnt Umber using a No. 4 sable brush.*

❷ *The middle-distance is blocked in with a deep olive using a No. 6 flat nylon brush. The basic shapes of the boats are painted in mid-gray. The foreground is added using a green made of Yellow Ocher and deep olive.*

❸ *The sky and water are painted in mid-blue, which is scraped back. If the artist feels a painting has become unworkable, it is necessary to scrape off the pigment and restate the drawing.*

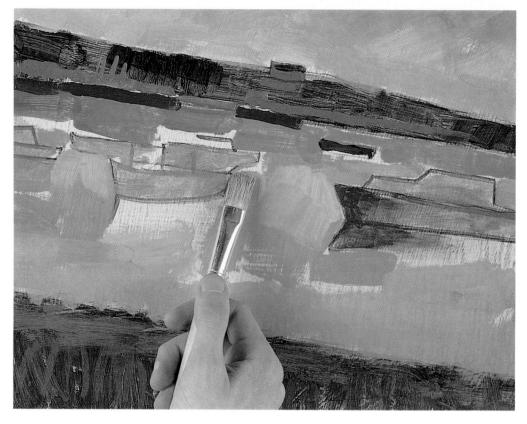

PAYNE'S GRAY COBALT BLUE TERRE VERTE BURNT UMBER YELLOW OCHER OLIVE GREEN MID-GRAY

121

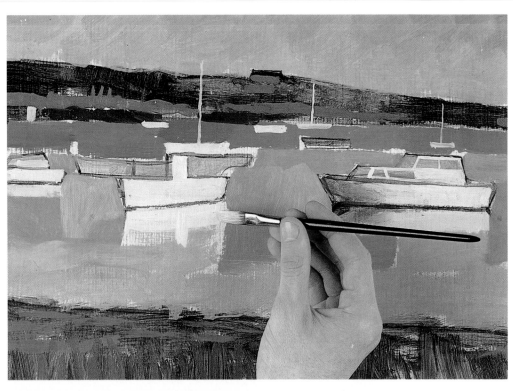

4 *Further tones of Ocher and Payne's Gray are added to the distant harbor. Details such as masts on the boats are painted in white using a No. 4, short-handled sable brush.*

5 *The sky is made lighter on the horizon. Reflections of the boats are painted with a No. 6 flat nylon brush and then smudged slightly.*

6 *The foreground is glazed in brown and reeds are added with a short handled No. 4 sable brush using a dry brush technique. Final details are added to the boats and to their images reflected in the water.*

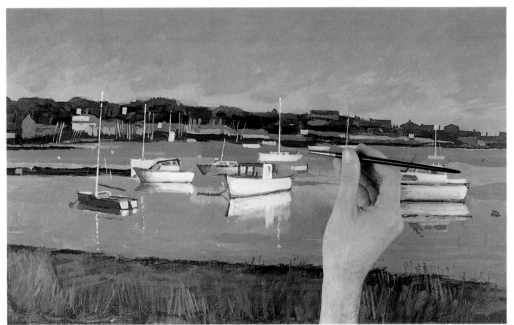

Travel • *Critique*

SOPHIE The color and pervading mood of this painting is quite different from the others. The sky, for instance, appears menacing rather than radiant. The light is concentrated on the boats so that they appear to be spotlit in an almost theatrical way.

To achieve this kind of subtlety of color, one needs to be aware of contrasts between warm and cool hues of color, and how they influence each other.

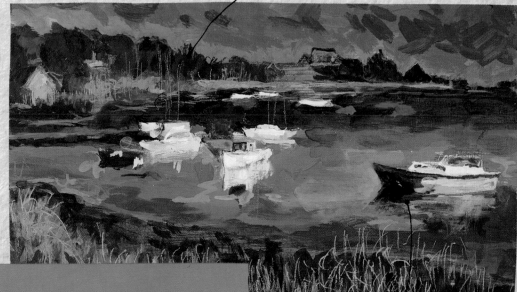

Good sense of place and atmosphere

Boats well lit

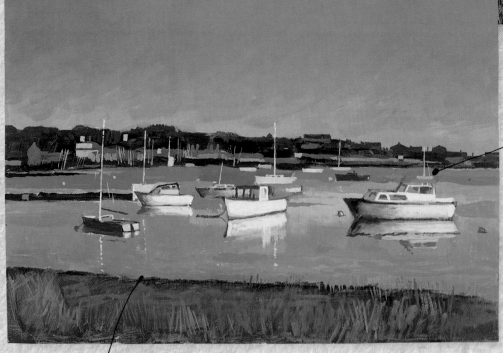

Everything is too symmetrical

JOHN The radiance of light in this painting has been handled well in terms of the medium. Compositionally, the disposition of various elements might seem too evenly balanced, although I feel that perhaps the subject demands this kind of equilibrium. The color and tone of the sky are reflected on the surface of the water, but I feel that there are subtle differences that the artist has failed to observe and record.

Needs to be more contrast in color and tone between sea and sky

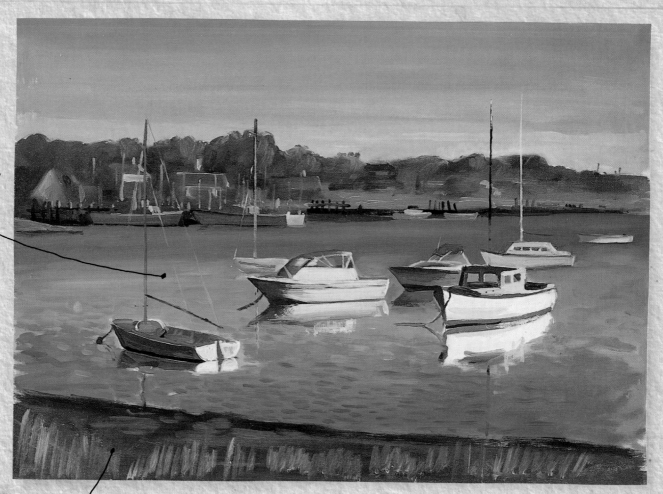

convincing
handling
of water
and reflection

Good
composition

ROBERT I am immediately struck by the handling of water and reflections in this study – in this sense it is more convincing than the others. By varying the consistency of the paint from thin washes or glazes to a thicker impasto the painting could have become more atmospheric.

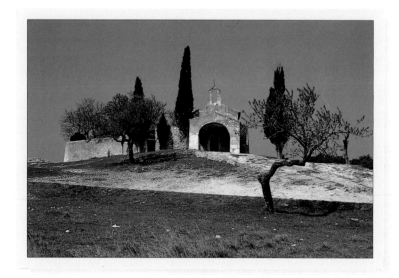

A Change of Scene

PROVENÇAL CHAPEL

The Alpilles form a limestone ridge between Avignon and Arles in France – this is van Gogh country. The outcrops of white rock sharply contrast with the sky, olive groves, and cypress trees. The twelfth-century chapel of St. Sixte is situated a few miles from the small town of Eygalières. It is built on high ground on the site where once stood a pagan temple dedicated to the spirit of the local spring water.

It is always difficult, I feel, to paint in a location that is closely identified with the work of a well-known artist. You tend to view the subject through the eyes of that artist. This project is concerned with very basic compositional problems – the chapel and surrounding walls and trees are fairly simple forms seen in

an elevated position. Therefore, the viewpoint can be critical. You need to walk around the chapel to view it from different angles before deciding on the viewpoint that best brings out the right balance of horizontal and vertical forms.

It is also a subject which, seen under direct sunlight, produces stark contrasts. Therefore, choosing the right time of day can also enhance the subject, greatly influencing the color and tonality of the painting. The subject seen at midday, for example, would correspondingly require colors to be mixed in a fairly high key – light excludes color. Brilliant sunlight tends not only to emphasize contrasts, but also to reduce the contrast between local colors. Generally, you should avoid contradictory effects of light and color.

sky handled particularly well

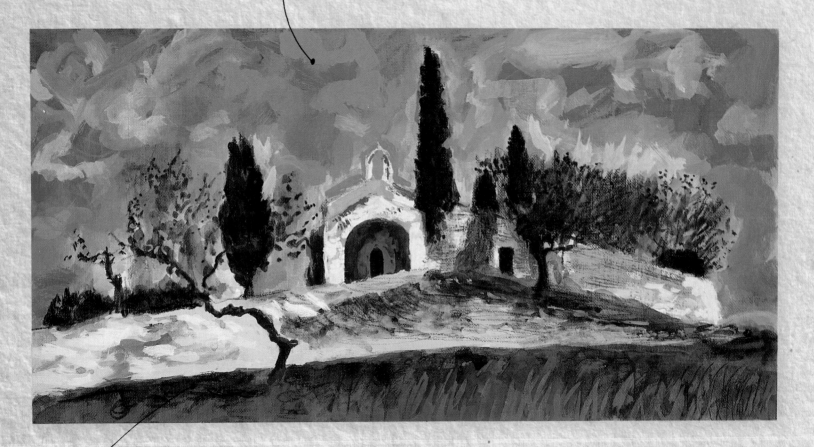

composition could be improved

SOPHIE There is nothing static about this painting and I feel that the artist has come very close to the spirit of the place. It has a strong rhythmic quality that recalls van Gogh's paintings of cornfields (which were painted in the same locality). In my view, however, there is an underlying structural weakness in the composition; elements within it appear to be much too compressed. I feel that the main interest for the artist has been in the painting of the sky.

Portrait

MAN IN A TURBAN

In his journal of 1850, Delacroix noted that, "the warmer the light tones are the more nature exaggerates the contrast with gray: witness the half-tints in the Arabs and in people of coppery complexion." You feel he could almost have been describing the subject chosen for this portrait.

We tend to see things in terms of contrast – the brilliant lemon yellow of the turban against the background and the leathery tone of the face. We normally think of portrait painting as an interior subject, where the pose, lighting and viewpoint can be carefully planned. In this instance, however, the subject is seen in direct sunlight, which produces sharp contrasts and saturated color.

A good portrait will reveal something of the personality of the subject. The face of our elderly Indian market trader, for instance, is deeply furrowed and bears the imprint of a hard-working life. His expression betrays a stoicism and an amused perplexity that anyone should want to paint his portrait!

Artist · Robert Williams

CADMIUM YELLOW

BURNT UMBER

RAW SIENNA

MID-GRAY

MID-GREEN

LAMP BLACK

133

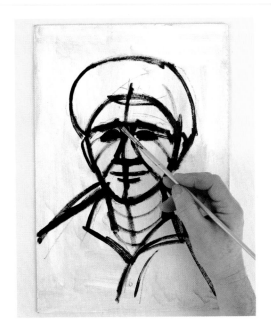

❶ *An underdrawing is produced on primed hardboard using a No. 6 flat hog's hair brush and Lamp Black.*

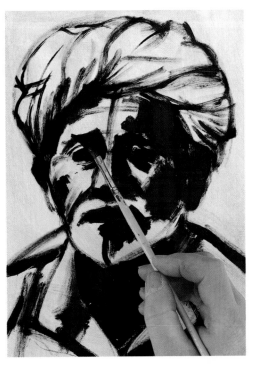

❷ *The drawing is further developed in terms of strongly contrasting areas of tone.*

❸ *The turban is painted with Cadmium Yellow and a green-gray is added to the shirt.*

❹ *The background is blocked in with a pale ocher. A mid-brown mixed from Burnt Umber, Raw Sienna, and Flake White is painted over the face and while still wet, paler tones of the same color are used as highlights on the forehead, nose, and cheekbone. The beard is defined as a dark gray.*

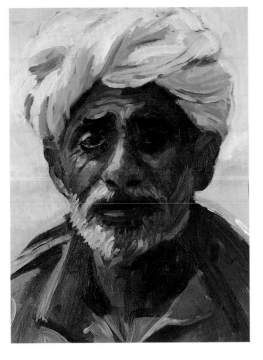

❺ *The texture of the beard is accentuated by using alternate strokes of white and gray. Everything in the final stage is resolved in terms of modeling and tonal values.*

Artist · Sophie Mason

1 *The main outlines of the portrait are drawn in oil pastel onto a primed board.*

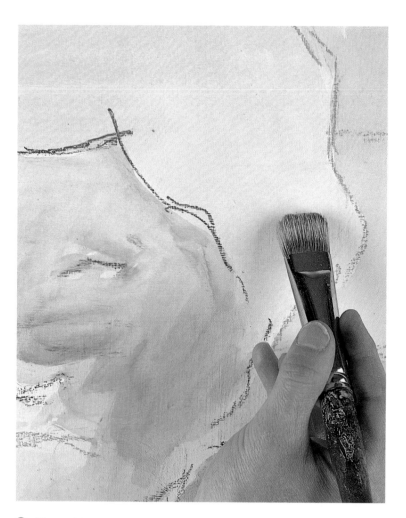

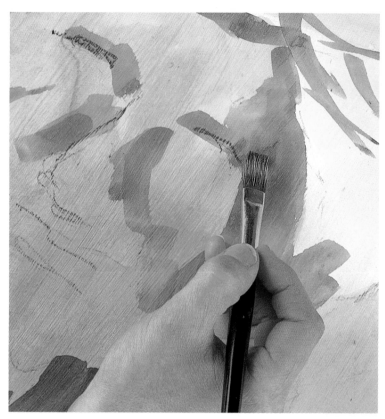

2 *Glazes of Cadmium Yellow, Vermilion, and crimson are overlaid on the turban, face and background. A neutral gray glaze is painted on the shirt using a No. 10 short hog's hair brush.*

3 *Details are broadly established with a thin glaze of Raw Umber. In addition, the artist indicates where light and shade fall on the head to suggest the modeling of the face.*

CADMIUM YELLOW VERMILION CRIMSON COOL GRAY RAW UMBER BURNT UMBER

4 *Tones are further modulated generally, using thin broad strokes of gray on the beard and shirt, Burnt Umber and crimson on the face, and darker chrome on the turban.*

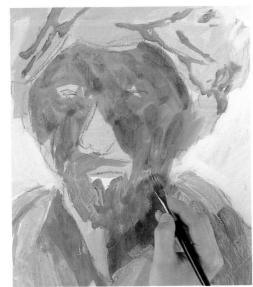

5 *Sharper tonal contrasts are established overall. Brushstrokes are still very free at this stage.*

6 *Smaller sable brushes are now used to bring greater definition and detail to the painting and to add highlights.*

Artist · John Armstrong

136

❶ *The primed board is stained with Raw Sienna and allowed to dry. The main proportions are marked in brown using a No. 4 sable brush.*

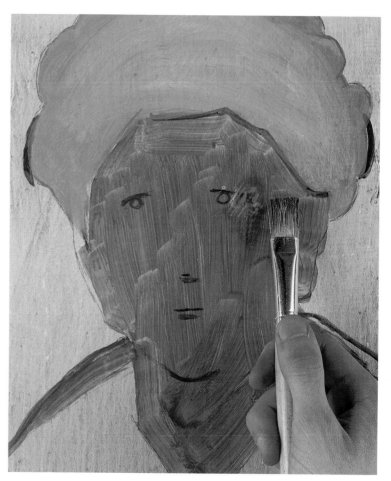

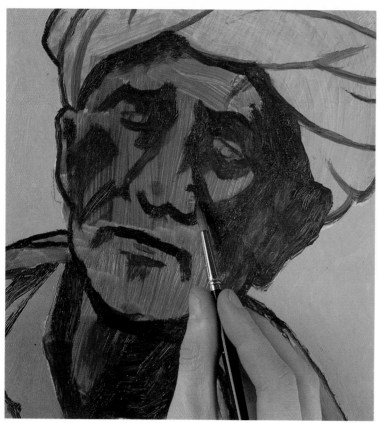

❷ *The face is glazed with Burnt Sienna using a No. 8 hog's hair brush. The shape of the turban is blocked in with Yellow Ocher.*

❸ *The folds in the turban are painted in brown. Darker tones are added to the face and a warmer tone painted over the background. The shirt is painted a neutral color mixed from Terre Verte, brown, Yellow Ocher, and white.*

RAW SIENNA

BURNT SIENNA

YELLOW OCHER

TERRE VERTE

WARM GRAY

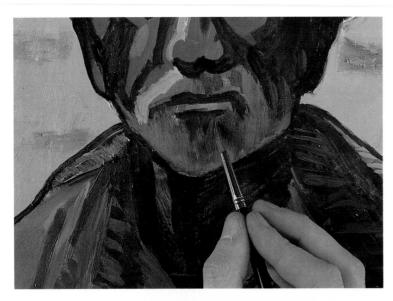

❹ *The modeling of tones on the face is continued using warm grays.*

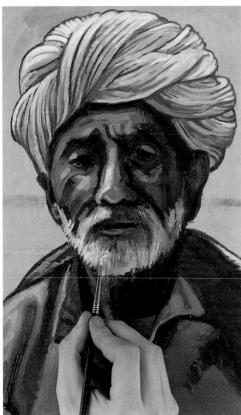

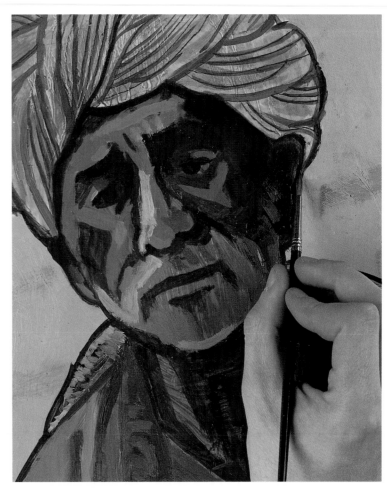

❺ *Lighter tones are painted on the face and more work done on the turban, using a No. 8 sable brush.*

❻ *Highlights are added to the turban and warmer whites to the nose and beard.*

Portrait · *Critique*

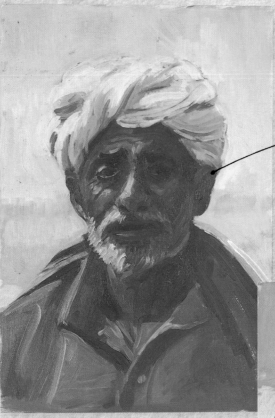

ROBERT The artist here demonstrates his ability to deal with the intensity of light. My only criticism is that the buttery impasto technique, which works well to suggest modeling, might have been contrasted with thinner glazes of color in certain passages of the painting.

confident handling of intensity of light

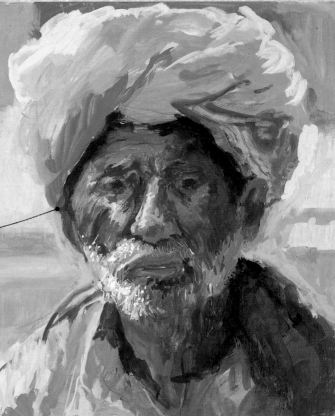

skillful handling of color values

SOPHIE In this painting the artist has somehow managed to get close to the subject so that right away I am riveted by the immediacy and character of the man. The technique of using alternating broad swathes of color with finer brushstrokes works well in this instance.

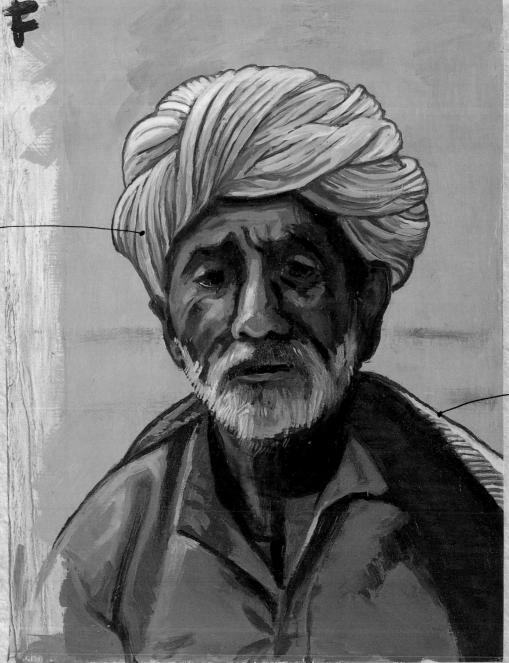

Folds in
the cloth of
the turban
are convincing

Could be more
tonal contrast
between
subject and
background

JOHN My attention was first of all directed to the way that the artist has resolved the drawing of the turban! The folds and intertwining of the cloth have been made plausible. The expression on the face has been conveyed equally well. My only reservation is that there could have been more tonal contrast between the subject and his background and that somewhere between stage 2 and the final stage something of the freshness of vision has been lost.

Glossary

A

AERIAL PERSPECTIVE

Sometimes known as atmospheric perspective. Creates the illusion of depth and recession by changes in color and tone as opposed to measurement.

ALLA PRIMA

The technique by which opaque paint is applied in a single layer to complete the painting in one session.

B

BINDER

The oil that gives cohesion to the pigment – enabling it to adhere to different surfaces.

BLOOM

A white or blue discoloration that can sometimes appear on the surface of a painting – most often when varnished.

BODY

Refers to the actual density of the pigment and its capacity in terms of coverage.

C

CHIAROSCURO

From the Italian, "light-dark," and refers to the degree of light and dark shading in painting.

COLD (OF COLOR)

All colors can be related to sensations of warmth or cold. Warm colors tend toward yellows, cold toward blues.

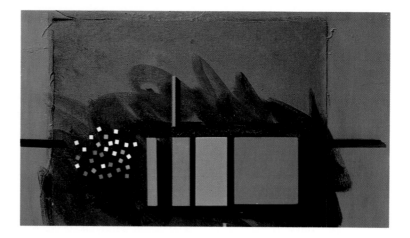

COMPLEMENTARY COLORS

Complementary colors are found opposite each other on the color wheel. A color is complementary to the color with which it contrasts most strongly, such as red with green.

COMPOSITION

The satisfactory disposition of all elements in a painting.

COPAL

A resin used in the manufacture of varnish.

DRY BRUSH

A technique in which the undiluted pigment is skimmed lightly over the surface of a painting leaving a broken effect on the grain of the canvas.

F

FERRULE

The metal part of the brush that binds the hair to the wooden handle.

FILBERT

A brush with bristles forming a flat, tapering shape.

FORM

A term that refers to the three-dimensional appearance of a shape.

FUGITIVE

Used to describe colors that are liable to fade in the course of time.

G

GESSO

A priming agent for canvas and boards made from gypsum.

GLAZE

To modify the painting by applying one transparent film of color over another.

GROUND

The ground coat of paint that makes a surface suitable for painting on. Can also be the first color laid on the surface as a base tone.

HALFTONE

A tone mid-way between black and white, or the strength between the lightest and darkest tone.

HUE

The color, rather than the tone, of a pigment or object.

I

IMPASTO

A heavy pastelike application of paint that produces a textured effect.

LOCAL COLOR

The actual color of an object, such as the red of an apple, rather than a color which is modified by light or shade.

MEDIUM

The medium is (a) the type of material used to produce a drawing or painting e.g. charcoal, pastel, watercolor, oil etc., or (b) a substance blended with paint to thicken, thin or dry the paint.

MODELING

Expressing the volume and solidity of an object by light and shade.

MONOCHROME

Refers to a painting produced with a single color, gradations of color, or in black and white.

MULLER

A heavy slab of marble with curved edges used for grinding colored pigment.

PALETTE

This can be (a) the surface on which the colors are mixed, or (b) a particular range of colors selected individually by the artist.

PIGMENT

The colored matter of paint originally derived from plants, animal, vegetable, and mineral products. Generally synthesized chemically in paint manufacture.

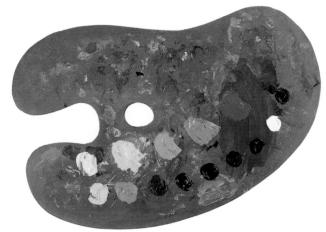

SCUMBLING

A technique whereby an opaque color is dragged roughly across another, producing a broken texture.

SUPPORT

The surface on which a painting is made (canvas, wood, hardboard, etc.).

TONE

The light and dark value of a color; for example, pale red is the same tone as pale ocher but both are lighter in tone than dark brown.

UNDERPAINTING

The first laying in of the underlying drawing in thin transparent paint.

WET-IN-WET

A technique that allows colors to merge randomly while still wet.

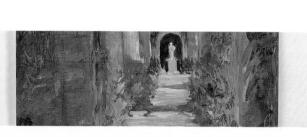

Index

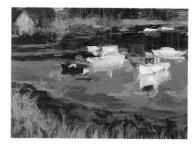
143

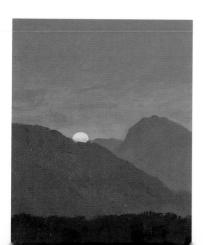